MW01275183

Revealing
The Evolution of an Artist's Soul

A True Adventure Story of a Quest for Enlightenment

Book One: A Spiritual Journey Trilogy

by Irene Vincent

Sun Door

Laguna Niguel, CA

First published in 2012 by

Sun Door

12 Doheny

Laguna Niguel, CA 92677

Copyright © 2012 by Irene Vincent

All Rights Reserved. No part of this book may be reproduced or transmitted in any form or by any means, electronic or mechanical, including photocopying, recording, or in any information storage and retrieval system without written permission from the author, except in the case of brief quotations embodied in critical reviews and articles.

ISBN-13: 978-1479299973
ISBN-10: 1479299979

1. Spiritual Enlightenment 2. Spiritual Transformation 3. Mind, Body, and Spirit 4. Art
5. Creativity 6. Memoir 7. Adventure

Interior Book Design: Irene Vincent website: http://www.irenevincent.com

Book Cover Design: Irene Vincent website: http://www.irenevincent.com

Cover Art: Irene Vincent, *Invitation to the Bird Realm,* 2005, Egg Tempera and Oil on a Canvas Board, 12 in. x 15.5 in., Collection of Artist, http://www.irenevincent.com

Dear Valerie,
May your life be filled
with many joyous
adventures!
 Divine Blessings,
This book is dedicated Irene

to my family,

to all my Spiritual Teachers,

to all my friends

and

to the creative and adventurous souls,

that we are.

Table of Contents

List of Illustrations

Fig. 67 I. Vincent, *Enter the Dragon*, 1983-84, Acrylic, Cheese Cloth, & Paper on Raw Canvas 53"H x 69"W

Fig. 68 Irene Vincent, *Journey of the Soul,* 1984, Acrylic, Cheese Cloth, & Paper on Raw Canvas, 65"H x 92 ½"W

Fig. 68A Irene Vincent posing in front of *Journey of the Soul* in 1984

Fig. 69 Irene Vincent, Photo by Jesi Silveria

In this book the art images are in black and white.

You may see these images and more in color at: http://www.irenevincent.com

Preface

As I taught my art classes and talked with friends, I usually shared stories about my visions, spiritual teachers and travels. They often told me that I had led an adventurous life. When people came to my house, upon seeing my art, they often asked about the origins of my images. As I observed them filling with enthusiasm from learning about the creative process, their authentic curiosity and interest inspired me to want to write a book that I had really been working on for many years.

Over the years I kept journals of my life, including significant dreams. I also researched the symbols that appeared in my dreams and in my art pieces. I came to realize that symbols are a profound way for the Universe to communicate with us. From this connection to the Great Oneness, I went through a process of healing, feeling more joy, wonder, and aliveness. This process took me into various levels of dreams and reality, revealing through experiences the mysteries of the Universe.

We all have similar mystical moments and experiences, but in the hustle and bustle of everyday life they are either immediately dismissed or soon forgotten. I hope by sharing my stories that your everyday life, spiritual life, and dreams become even more adventurous and conscious than they already are.

In art the debate persists: how much should we allow the viewer of a painting to decide for him/herself the meaning of it? To me personal interpretation for the viewer is very important because his/her perceptions are nourishment for his/her own psyche. And I also believe it is beneficial to know the context in which the work was made, the meaning the artist wished to convey as well as the meaning the artist might have become aware of and how the art transformed the artist. This information can give the viewer an enhanced experience.

Also in 1984, I met Swami Radha. After hearing my story of escaping poverty, managing an education, and becoming financially independent, she encouraged me to write a book. I told her I hadn't accomplished all that by myself, other people had helped me. She said, "Yes, they are part of your story."

In 2001, I planned to go back to college for my master's degree because they were going to let me write a book as part of my program. In order to get accepted, I had written the story's basic outline of all the formative experiences of my life from age three. Unfortunately, I was going to have to fly to San Francisco once a month. With 9/11 fresh in mind, after being accepted, I decided against it.

In 2011, I decided to finally write a memoir/art book of my transformative journey seasoned with my art. I wanted a true adventure story that read like a fast paced novel.

I made a timeline from my art, my journals, my formative experiences, and travel pictures. I kept holding faith that I could remember in their truest light people's names and my experiences with them. If I had difficulty remembering something, the universe eventually provided it. During such difficulties, I would say, "Okay God, if you want this book written, you have to help me." Then, after a nap or a walk, a memory would shine on through and I would run upstairs to my office and type it. Sometimes as I typed, memories channeled through like a lucid dream onto the page. Like painting, the whole process became exciting and invigorating.

With all this said, if I didn't remember a name or experience quite the same way as another person, please forgive me. Sometimes I changed a person's name because I felt they might have wanted it that way.

It was embarrassing at times, revealing some of my life's stories. I hope, though, that as I reveal myself, you will gain some revealing insights into parts of yourself, so that you may self-heal and awaken to new possibilities.

This part of my story ends in the midst of 1984 as I had become enthusiastically committed to my soul's journey.

Introduction

*A*s long as I can remember, God has been my divine protector, my best friend, my all-loving, all-forgiving, and guiding force with whom I have always spoken. On a seemingly ordinary day, a near death experience caused my life events to pass before my eyes like a movie. Even though I was only nine years old, the flashing scenes beckoned me to reflect upon my life and to make new choices. This near death experience forever changed my concept of time and intrigued me with the mysteries of the human brain. Ultimately, it put me on a spiritual quest, seeking ever-grander mysteries.

My journey has taken me on many paths. I have explored life from the ghettos, from poverty, from relationships, from the entrepreneurial business world, and from the perspective of an artist. I have traveled and experienced many cultures, along with exploring the esoteric arts. I didn't understand it at the time, but all of these paths were leading me to a spiritual understanding of life—transforming my soul.

At nineteen, I had an identity crisis. During one particular long night, I analyzed my life's events, dating back to when I was three. I questioned, "Who am I? What do I want to do with my life, rather than just listening to people around me telling me what I should do?" From this, I rediscovered that I had always wanted to be an artist, but had been stifled in the hardly supportive school environment. Because of these realizations, the next morning I boldly walked into an art store to buy paints and canvas. I started painting.

As I grew older and had another near death experience, I came to see such incidents as divine intervention, a way of reviewing my life's choices, of renewing urgency in my cause, of keeping my soul on its evolutionary path. I hope by reading this story you remember the ways the divine has intervened in and influenced your life.

I also hope to inspire people to realize the power of art: its power to convey emotions, to take us deep into our souls, to make the world around us more colorful, to enhance our aliveness, and to awaken the ancient and sacred wisdoms within us. The Divine Universe speaks to us through dreams, visions and images. In this book I share the contemplations and visions that inspired my different art pieces to give readers a deeper understanding of creativity so that they may, perhaps, tap into in their own.

In this first book of my trilogy, I explain the makings of my different art series: surreal, geometric abstract, organic abstract, expressionistic, political, and their transformation into my shamanistic-spiritual art.

My surreal art expressed my philosophical ideas. Since I was young, I had an idealistic desire to somehow alleviate suffering that humans imposed upon themselves and each other. Through surreal art I sought to introduce strange worlds that people would be drawn to and feel safe in, rather than feeling fearful of those worlds. I hoped that this love for my strange worlds would open their hearts to appreciate the unique strangeness of other cultures and belief systems.

Through my geometric abstract art, I explored qualities of expression through contemplating words. To my surprise, by contemplating geometry and space, these images led me into their own abstract world.

Then my abstract art went organic (free form) when I moved to California. I wanted a new freedom of expression. As my figure drawing abilities developed, I explored human emotions and human qualities through my expressionistic figurative images. From those images, my desires for society's transformation led me to make political art.

My political art was an important part of my transformation because when some of my images shocked me, I decided to change my philosophical questions from: "What are the problems in society? How can I shock people into awareness and into taking action to alleviate the problems?" ... to asking: "What is a powerful love, a love beyond sentimentality, a love that includes self, family, friends, all humans and all life forms?

What would these images of love look like?" These new questions led me to explore shamanism in my art and in my life. I ended this part of my story with my painting, *Journey of the Soul* since it was a ritualistic act, a self-initiation, and a crystallized commitment for making my soul's journey as my primary purpose in this lifetime. I hope that my story inspires you to listen, trust, and follow your soul's journey.

Chapter One

Divine Intervention and Early Yearnings
For Art & Love

Ψ

Influences From the Beyond

Who would think that a seemingly ordinary day would become the near death experience that catapulted me into the mystical side of life? It all began during the dying days of an Indian summer.

A ten-foot high wire fence loomed over my friends and me. This steel and wire fortress guarded the football stadium. Somehow, we always managed to get into the events without paying. We persistently circled the stadium until spotting a way in. After our third or fourth circuit, a gate guard would sometimes take pity on us kids and let us into the stadium. Once in a while, a marching band student would sneak us in through a side gate. Other times, a more willful intruder left a hole in the fence. Today we found such a hole. Danny and Lynn helped each other through first.

Danny struggled to hold the defiant fence open.

As I rushed to squeeze through the opening, Danny said, "Irene be careful. The wire fence has lots of sharp edges. I'll hold it best as I can. Move fast before it slips out of my fingers and cuts you."

I slipped through.

"That was close," he said. "Are you okay?"

I replied, "Yeah, but that rusty wire scratched me a little bit."

Danny didn't care. He just said, "You and Lynn help me hold it open wider for Sharon." Sharon was a well-fed Italian girl whose appetite revolved around lots of pasta.

Once she was through, Danny asked, "Are you okay, Sharon?"

"Yes, but I don't want to come in that way again."

Ignoring my bleeding scratch, I said, "Let's go get some hotdogs and drinks before we search for empty seats."

Sharon perked up. "Sounds good to me."

With hot dogs and soda held in each hand, we sought unoccupied seats. The game was afoot, and people were yelling and cheering. No one was paying attention to me – including me. As I gorged on my hot dog, one bite lodged in my throat. I was choking!

I tried to cry for help, but I could only make a silent coughing noise. The roar of the crowd overwhelmed my desperate attempt to get the attention of my friends, who were rooting for their home team. The stadium, its noisy crowd, and the game suddenly froze and faded into silent gray, while my brief life of nine years, passed before me like a Technicolor movie. In the few seconds of my helpless gagging, memories of my wildest emotions rushed through my body, and my life's events streamed through my mind, revealing the effects of all my unconscious choices. Thank God, the hotdog finally slipped down my throat, and the world came back.

"Didn't you guys see me choking?" I yelled at my friends. "I could have died! What kind of friends are you?" I followed this outburst with, "I just had the most amazing experience."

Dan turned to look at me and said, "You just missed a good play." He and the others continued to talk about the game. For a moment, I stood there silently and stared at them. Dejected and exhausted, I slid myself further down the bench to replay the movie that I had just seen in my mind.

I remembered one scene where my mom and some women friends were talking.

One woman said, "What about Lady Godiva with long hair riding naked on a white horse? Men liked her for the way she exerted her freedom of thought."

And I thought, *Freedom, that's a beautiful picture. I would like to be this lady riding nude upon a horse along the shoreline of the ocean.*

Another woman interjected, "Yes, but what about that stripper, Gypsy Rose Lee? The men really like her. They buy her diamonds and cars. She doesn't have to worry about anything."

And I thought, *Wow, I want to be a stripper when I grow up! Men will like me and buy me pretty things.* Even though I had innocently made this inward declaration, I didn't know the repercussions of that kind of life. Now, as I recalled this scene, I was totally embarrassed. I had recollection of a voice telling me that was the wrong way to go. And now I felt naked before God.

I resolved to study hard in school and make my way in the world the best that I could. Whatever that meant. After reviewing some more of the decisions or imaginings that I had previously made for my future, I decided to change them for my betterment.

As I sat sweating on the sticky bench, I pondered, *Wow, did I just face the Judgment Day the priest told us about in religious instruction class? Or, was I dead for a brief moment?* I sat there in awe of the power of the human mind to recall nine years of events that I had forgotten. I was amazed how completely my brain had reviewed my whole life in a matter of seconds. *How was this possible?* My concept of time was forever changed.

After this mysterious experience, I found myself drawn to books that talked about dreams and other ways to access knowledge. Since I could not afford to buy books, when I went into bookstores, I would read the titles; especially those that stimulated my imagination, or that featured anything magical. I dreamed that someday I would have access to knowledge of the arts, astrology, astronomy and other metaphysical arcana.

Ψ

Yearning for Art

Sometime thereafter began my fascination with art. When my fifth-grade class visited an art museum in Rochester, New York, I stood mesmerized in front of a realistic painting of the back view of a beautiful female nude model. I found this artwork magical. I thought, *the colors are vivid and the image is so alive. The people look real. How is this possible? How can a human being have such an artistic skill?*

I stood there relishing every detail until Mrs. Bush called, "Irene, will you please stay with the rest of the students? We don't want to lose you."

As I was torn from my contemplation, I yearned to create this magic on canvas.

My next adventure with art occurred a few days later when Mrs. Bush said, "While you children are on lunch break, stare at your face in a mirror and study your features for a few minutes. Remember what you see so that after lunch you can draw your face."

At home during lunch, I stared so intensely at my reflection in the mirror, that it scared my mother.

"Are you all right, Irene?"

I looked at her. "Yes Mom. We're supposed to memorize our faces and draw them when we get back to school after lunch."

"Well," she said, "it's getting late and your lunch is getting cold. Come and eat your food." I loved how mom always included a surprise dessert with our soup and half a sandwich.

Reluctantly I pulled myself away from the mirror. Afraid I'd forget a facial feature, I ate quickly and rushed back to school.

Soon as us kids were seated back in the classroom, Mrs. Bush handed out paper and charcoal. "You have fifteen minutes to draw your face."

Looking around the room I saw that the other kids were just as nervous as I. Yet, we all started drawing.

It seemed like only moments had passed when Mrs. Bush said, "Time's up, put down your charcoal." She collected our drawings, taped them onto the wall and pointed to each drawing in turn. "Raise your hands if you recognize the person in the portrait." All the students raised their hands when she pointed to mine. "What makes this picture recognizable as Irene?" she asked.

Julie said, "It's her hair."

Billie said, "I recognize her eyes."

Johnny said, "I can see her smile."

Susan said, "It's the shape of her face."

And obnoxious George complained, "This isn't fair. Irene is unique, so it's easy to tell her apart."

Mrs. Bush shook her head. "Each of you is unique, but Irene was better able to remember and draw her features."

This experience lingered in the back of my mind and I thought, *Wow, someday I just might be able to capture the magic I saw in the museum.*

I was so inspired. I wanted to continue making art, but Mrs. Bush wasn't really allotted time to teach art. Inspiration turned into disappointment.

"When are we going to get to paint?" I kept asking her.

"Be patient for a few more months," she kept telling me. You'll get to make art with the shop teacher for a few hours during a two-week period later this year." That year we made clay ashtrays. The next year we made little boxes out of ice cream sticks.

Ms. Cox was our new teacher. I hoped that maybe she could change things.

I said, "Ms. Cox, the art class was dull. We were told exactly what to do. We had no chance to use our imaginations. I want to paint."

Reluctantly she admitted, "I'm sorry, but that is all the school offers."

Thank God for Ms. Monfort, the music teacher and our temporary art savior. She was working on some kind of paper for a degree. She came into our classroom for the half-hour each week while the Philharmonic Orchestra aired over the radio.

Handing us paper and crayons, she said, "Now lay your heads in your arms upon your desks and let your imaginations soar. After about ten minutes, start drawing as the music moves you."

The music soared through my mind as colors swirled and danced. Those ten minutes seemed like hours. During the next twenty minutes, I drew feverishly and exuberantly. I felt happy beyond my wildest dreams. Each week I looked forward to Ms. Monfort's coming, but she always took our drawings. After a few months she had enough material for her project, and my newfound joy ended. However, I'm forever grateful to her.

After this experience with Miss Monfort, not only was I more enthusiastic than ever about creating art, but also I came to love classical music. Soon after I started drawing at home. Then I noticed some boys drawing images of cars during class. I started doodling and drawing images while the teacher lectured us. I actually felt it increased my ability to hear her.

But when she noticed us drawing, Ms. Cox said, "Art is not important enough for class time." Once again, my aspirations were stifled.

<div align="center">Ψ</div>

Day Trip to the Ghetto

It had only been a year or so since my family had moved to this suburban neighborhood. I had experienced my near-death experience and now desired to create art. I had made some new friends here, but I was still feeling lonely. Mom had divorced dad when I was seven years old, though he continued to spend every Sunday with my siblings

and me. Now that she was married to Frank, we rarely saw our real father. I also missed my friends from the Afro-American neighborhood. I remembered how anytime I ran outside our apartment building, I would automatically have several friends to play games with. Now I had to call my friends on the phone and see if they were available to play.

One Saturday morning, I asked, "Mom, do you think that you could get Frank to drop me off at Building 7 so I can visit Tee Dee and some of my old friends? I really miss Tee Dee."

Mom looked shocked. "Surely, Irene, you don't want to go back to that place," she replied.

Making a sad pouting face, while sticking my bottom lip out to emphasize it, I said, "Yes I do!"

Mom always could see through that sad facial expression of mine, a determined will power implying that I was going back to my old neighborhood even if I had to walk.

"Well," she said, "I'll ask your stepfather. We'll only drop you off, though. It's too dangerous for us to go there, now that we don't live there. I want you to go right to Tee Dee's apartment. We'll pick you up in two hours. Be at the same spot waiting for us."

As they dropped me off at the street side closest to Building 7, my parents exclaimed in unison, "Be careful."

"I will." As I scanned the project, I prayed to God to protect me. Then I walked directly towards Tee Dee's apartment. The sunny sky was starting to accumulate gray clouds. I was trying so hard to be happy in this world of gray. Even all the walls in the school were painted gray. I hoped that it wouldn't rain today. I knocked on Tee Dee's apartment door for so long, that a little boy from a nearby apartment opened his door.

"Who are you looking for?" he asked.

"I'm looking for my friend, Tee Dee."

"Her family moved away last year."

"But, I came a long way to see her. Did they really move?"

7

"Sorry, " he said, shaking his head as he closed his door.

Maybe Betty Jean would be home, I thought. *Oh God, she lives up on the fifth floor and there is no way I'm going up the stairs or in the elevator alone. It's just too dangerous.* I remembered being stuck between floors in the elevator, but worse than that, I also remembered the stories of little girls being raped in the elevator. I stood near the elevator. I saw a lady step into the elevator, so I jumped in after her and I pressed the button for the fifth floor. I knocked and knocked on Betty Jean's apartment door, but no one answered.

How can everyone be gone on a Saturday? Now I have to go back down the elevator. I'll press the button and stand back from the door, and I just won't get on until a woman is riding down or some kids. After two tries I made it back down to the first floor.

Next, I decided to visit my friend Robert. We had become friends six months before I left the neighborhood. Robert lived about four buildings over and on the third floor. *I sure hope that I remember which apartment he lives in.* As I walked towards Robert's building, two boys and a girl ran towards me.

"Hey, white girl," one boy called out, "what are you doing here? You don't belong here. You know you could get beaten up." There was hint of a threat in his voice and anger in his eyes.

I smiled, hiding my fear. "I used to live here . . . you know. I came to visit friends. Could you protect me and walk with me to my friend's apartment?"

"Who's your friend?"

"His name is Robert. I remember that he lives in that building over there," I pointed. "I think he lives on the third floor. Oh, my name is Irene. What are your names?" I looked at all three kids.

He replied, "My name is James. This is Lisa and this is Billy. Sure, we can walk you over. I think I know Robert. Is he going into the fifth grade?"

"Yeah. That's my next grade, too."

As we walked down the sidewalk, I asked them if they knew any of my other friends. Apparently, a number of my friends had moved. I didn't know how that was possible in such a short time.

After knocking on a few different doors, we found Robert who was surprised to see me. He said that he heard I had moved away. Robert and my new bodyguards talked with me in the hallway until it was time for me to leave. I felt depressed as I left them. I went to meet my parents.

"So, did you have a fun time?" Mom asked.

"It was okay," I said. "But a lot of my friends have moved. I don't belong here anymore." I felt such nostalgic sadness.

The muscles relaxed in my parents' faces. Mom's body sunk gently into the car seat. Frank's hand reached out, patting her thigh. She smiled at him and then turned around to face me again.

"Let's go out to dinner," she said. "Then we'll pick up Lady (Lady was my dog) and go for an ice cream cone."

<div align="center">Ψ</div>

Being a Minority Among Minorities

I squirmed in the back seat of my parent's car as thoughts about my life in the ghetto bubbled up in my mind. Until I was nine, my family lived in a ghetto that was ninety-eight percent African American people. Through the third grade, I was the only white girl in my class. Of course, I didn't know that my friends were a minority. I didn't even understand why so many people on TV were white.

We lived in one of seven fourteen-story apartment buildings surrounding the concrete desert of our playground. And yet, played out in this cement oval was a world of

performance art. Even among the traumas of the ghetto, I remembered some wonderful experiences. Often in the summer, the old black men would set up a stage for singing and tap dancing contests. My friends and I would watch with total fascination, imitate their performances, and add our own spontaneous tap dancing, cartwheels, and springing back to our feet from the splits (so easy for small girls), lost for a while in the rhythms of our games. Dancing and singing were all around me. Dance was one area of free flowing expression for me. Somehow the music automatically traveled through my body and made me dance.

Then I remembered one of my worst experiences happened when I was four. Mom and I had walked a short way from our building when we saw Ruth, my nine-year-old sister playing in the cement oval area. Mom yelled at Ruth to come home for dinner, but Ruth kept playing. Jasmine, a black lady who was walking by with her own daughter, misunderstood my mom's words, and thought that they were directed at her daughter. I saw Jasmine's whole body exploding with anger.

Jasmine's eyes widened and her nostrils flared, and she yelled, "You got no right to talk to my daughter like that!"

I held tight to my mom's hand while whispering, "Mommy be careful."

But Mom was defiant and said, "I'm not talking to your daughter or to you." Jasmine chased us to the front cement area of our apartment building, still screaming at us. She grabbed my mother by the hair and started to beat her as my sister and I watched with horror. We started crying. We were in shock.

Surrounding Jasmine and Mom, a gang of black people formed a circle and started yelling, "Kill her! Kill her!"

My sister and I were terrified. We wanted to stay by Mom's side, but knew we had to get help. We ran up the four flights of stairs to our apartment and called the police.

My mom was carried away in the ambulance and spent a month in a hospital. Jasmine spent a few months in prison. Since my father worked all day and had a routine of drinking

alcohol after work, my brother Ed, my sister Ruth, and I were taken to a foster home located on a farm outside Rochester. Although we were treated well, we never felt protected or secure. I felt deserted and scared. We prayed for our mother's recovery. After an eternal month, she showed up in a car to take us home.

We moved away from the predominantly black ghetto, to a merely low-class white neighborhood and lived there for a few years. Eventually, it was safe for Mom, Eddie, Ruth and me to move back to the housing project. Apparently, while Mom was visiting her best friend, Agnes, who lived in the project, Jasmine saw mom and formally apologized for hurting her. They became friends. That made mom happy because within their friendship was sealed an unspoken oath that Jasmine would protect mom.

Mom and Dad had separated just before we moved back to the project. My mom worked, but we still needed help from welfare services, and this was where the welfare made us live.

Mom was probably one of the cleanest people in the building. We lived on the first floor across from an incinerator opening with a metal closure. People were supposed to throw their bags of garbage through the opening to land in the furnace in the basement below. Children and some adults often left their bags of garbage toppled on the floor. Mom would often be in the hallway cleaning up the spilled garbage. She didn't want our apartment to get cockroaches.

Whenever anyone came to our apartment, they always said, "Wow, Mrs., you have the cleanest apartment I've ever seen! How can you possibly keep it so clean with three kids and all?"

Mom, lighting up like a decorated Christmas tree, always replied, "Oh, my mom used to call me "Spic 'n Span." I just like things clean." She took great pride in cleanliness. I know this because she was always making me pick up my toys or throw them away.

I remembered how proud I was when I painted an old wooden crate bright red. I set it on my little play table and announced it was my bookcase. I placed my three precious books into it.

Mom shook her head every time she looked at my bookcase. "Surely you don't need that book case, Ireenie." She was using my sweet name "Ireenie", even though she wasn't feeling all that sweet toward me at the moment.

"Yes, I do," I said. "It's so beautiful! I painted it such a bright red. It cost me fifty cents for the paint."

Eventually, Mom's constant nagging wore me down and I finally relented, "Okay, Mom, you can throw it away. I'll find another place to put my books."

At that time, food was scarce in our apartment. It seemed as if we only ate macaroni, cheese, and eggs. Sometimes we ate fish on Fridays. I loved it when Dad came to take us kids to his apartment on Sundays. He often cooked us a delicious meal of fried potatoes, meat and vegetables. Then he took us for a hike in nature, or to the zoo, or fishing, or sent us to a movie. Sometimes our Italian uncle Al invited us over to his house for homemade pasta and marinara sauce. Grandma and my sister Janie, who was six years older than me, lived in the apartment across from my Aunt Dolly. My aunt Dolly and Grandma made us pies and cakes. Aunt Dolly designed and sewed all her own clothing, which really impressed me. My cousin David, Uncle Al and Aunt Dolly's only child had all kinds of toys and books. It was a thrill and a relief to visit them.

As I grew older, our vertical slum became a scarier place. Just visiting a friend on an upper floor felt like a military maneuver. Alone, I would slowly climb each flight of stairs, peaking around corners, making sure no drunk or rapist lurked on the stairwell. Girls got raped in the hallways, mostly near the basement entrance. Sometimes we could hear their screams and mom would call the police. These stories with all their gory details would go around the project. The building had an elevator, but the other kids and I would only ride in it if there were at least three of us.

Tiny and white, I was often the last person chosen to play on any team. Sometimes the other kids made me just sit and watch them play a game. During those times, I felt rejected and humiliated. I developed empathy for the underdog. I cannot bear to see this happen to anyone.

I became street smart by watching people's body language and observing the tricks they played on other people. I learned compassion by seeing the needless pain people inflicted upon one another and by seeing the affection my friends' parents poured on their children. They often told us jokes, making us laugh. Many of my friends' parents also invited me to their churches where the people sang with overwhelming love, emotion and devotion. Their churches were a source of great joy to me.

Although I was petite, I became a fast runner. Because I was a white girl, every so often the other kids would decide they were going to pin me down and put ants in my hair or perform some other small act of torture. I usually got a running start, but was often chased for miles. Breathless, I once rang a stranger's doorbell and asked the lady to let me into her home to hide until the other kids tired of looking for me. By the time I made it back home, the kids were onto another game.

Fights between teenage boys and men were frequent, egged on to excess by crowds that appeared instantly from nowhere. Sometimes I stood with my friends, watching these horrid fights and crying with fear and compassion, identifying with those in pain. I would ask my friends to leave with me, because I was too scared to leave alone. Sometimes they did; sometimes they didn't, as when one young man's head was split open and bright arterial blood streamed down the cement curb. It was so difficult to get these violent images out of my mind. They played over and over. When I saw violence on TV, I felt the pain of the victims, so I often had to leave the room. I became scared of any type of gathering of people because I felt that the crowd could easily become unruly.

One night Ruth and I were alone in the apartment. I called to her, "Ruth, come listen. Some man is calling the other man a dirty f...en bastard."

One man yelled, "You get that knife away from me, you nig...r." Screams of agony followed. We heard bashing and thumping sounds of bodies hitting against hard surfaces.

Ruth cried out, "Oh my God it sounds like they're killing each other. Someone has got to call the police. But I don't think that we should."

We stood there, scared to death, behind our locked apartment door. Finally, we heard sirens and then lots of people shuffling around. Then it grew ominously quiet outside.

The next morning, I shivered from seeing fresh blood spattered all over the walls in the main entryway. I ran outside to play.

Thanks to Miss Curry, my third-grade teacher, I learned that there might be better places to live. Miss Curry was also my first black teacher. She cared about us. One sunny day, she gave us a strong, impassioned lecture on the importance of education, including the levels we needed to traverse: grammar school, middle school, high school, and college. She emphasized why we really needed to go to college.

"When you children grow up," she said, "education is your only escape from the ghetto."

I raised my hand. "Miss Curry, I have lots of playmates and I don't understand why I need to escape from where I live."

"Once you become an adult in the ghetto," she said, "your life is always in danger and you always need to protect your children and your home. If you own anything, the people here will destroy it or rob you of it. You need to get an education so you can have choices in life." She convinced me, because I already knew that as a white adult, my life in the ghetto would be even more at risk. So on that day, I decided that I would study hard. I would go to this place called college.

Also in third grade, we were given Intelligence Tests. None of us really knew what that meant. The tests seemed meaningless to us. A few weeks later, Miss Curry announced, "I want you students to know that three of you from my class received the highest scores on the Intelligence Tests. The best scores went to Robert, Irene, and Ginny. I'm

encouraging you to always study hard so you can go to college. But remember, all of you have the ability to go to college." She went on, "As a reward, we're having a class play. I'm going to give Robert, Irene, and Ginny first choice for the leading rolls. You're to remember your lines and then we'll practice your parts."

This news encouraged me to think that I had a chance to go to college, and I was excited about being in a play.

Upon returning from my trip back to the ghetto, I was able I to release my past. I felt sad that I'd never see my old friends again. I guess I needed to be grateful for my new life.

<div align="center">Ψ</div>

The New White Neighborhood

I thought about how quickly things had changed. Shortly after Miss Curry's speech about leaving the ghetto, my mother met a man named Frank. They really liked each other. However, he was afraid for his life whenever he came to visit her in the project. A white man was forever a marked target. So when Frank asked my mom to marry him, she accepted and we immediately moved, temporarily into my grandmother's apartment. We lived there for two months.

It was a slightly better neighborhood, but it took me two bus rides to get to school. Mainly I liked it there because I had a chance to get to know Grandpa George. He didn't live with my grandmother, but he always lived near her. Grandpa had a secondhand furniture store down the block from my grandmother's apartment. I visited him everyday. He had a little chair that was always sitting next to his big chair, and I always sat in that little chair. As he told me stories, every now and then, his friends stopped by and started telling their stories. As close as I could figure out, Grandpa had been a gypsy or had hung out with gypsies. They talked about traveling, Indian tribes, and rounding up wild horses.

However, unfailingly, as the words "wild women" spurted out of someone, or the story seemed like it was gaining momentum, Grandpa always said, "Hang on, guys. Irene, here's a quarter. Go buy yourself a soda and a comic book. Go play now."

"But, Grandpa." I would stand up from my chair, stamping my foot, "The story is just getting exciting!"

Lovingly, he laughed, "Scoot, now."

Well, even if I didn't get to hear about the wild women and Indians, I was happy anyway. I scored a quarter.

In the late spring, Mom married Frank Twamley, my new stepfather. Then Mom, my brother Ed, my sister Ruth and I moved to what I called "the white neighborhood." We were still poor in comparison to our neighbors, but we had a nice little house with a huge yard bordered by rows of fragrant flowers. Vacant lots filled with trees surrounded us. I loved playing among the trees. Eventually, new homes filled those lots. I often played rolling on the grass with Frank's collie dog, Lady, along with two neighboring collie dogs named Lassie and Ginger. The dogs hung out at our house.

We also had several cats. My favorite cat was Tarzan, appropriately named because he liked to hang and swing on my mom's curtains. Because of Tarzan, all the cats had to sleep in the garage with the dog. I groomed all the animals and played games with them.

Because of my background in the ghetto, I tended to stand out in the new white neighborhood. I had a black southern accent and used unusual slang. Since I was living in Rochester, New York, people kept asking me where I was from. As a joke, I finally said that I was from the southern part of Rochester.

I was a good runner, too. When I was running around the track at school, I was able to pass the tall kids.

One of the tall kids asked the gym teacher, "How is it possible that Irene can run so fast?"

The gym teacher answered, "I'm not sure."

My secret, of course, was that I was imagining that kids from the old neighborhood were chasing me and I was running for my life. And I never told my new friends that.

Despite my diminutive stature, my ghetto experiences gave me a sense of fearlessness and a preparedness to defend the weak. During grammar school, I walked my neighbor's five-year-old daughter, Sheila, to school. Sheila had psoriasis, a scaly skin condition, and I warned the other children not to make fun of her or hurt her in any way. One day, Johnny, a boy twice my size, threw snowballs at us. His snowball hit Sheila and made her cry. Braving the barrage of flying snowballs, I attacked him, tripped him, threw him down, sat on him, and gave him a bloody nose. I made him promise not to throw snowballs again and then I released him.

After lunch, while we were all standing in line at school, the other children clapped, laughed, and congratulated me for giving the bully a bloody nose.

"You were beat up by a girl," one boy teased.

Another kid said to him, "Irene's so little and she knocked you to the ground. You're such a wimp."

I started to feel sorry for Johnny. "Hey," I said, "it was luck that I was able to throw him to the ground. It's not right to make fun of other people."

Surprised to hear this, Johnny turned and looked at me. I whispered, "I apologize, but don't mess with me or with anyone else."

While the principal secretly approved my action, he had to punish both Johnny and me for fighting. We got detention. I didn't totally understand why I got punished for defending Sheila and myself.

Ψ

Growing Up: Lessons

One of my first lessons in responsibility came when I wanted to buy a used bike from a friend for twenty dollars. My parents decided that I needed to earn the money. So I started weaving potholders on a loom. I made them as pairs in matching patterns. It was fun coming up with different combinations of patterns and colors. Then I sold them door to door for fifteen cents each, or two for twenty-five cents. Some people were kind to me and praised me for working. However, once in a while a person told me that it was against the law for me to sell door to door. I got praised and I got scolded. But, I kept thinking about my little bike waiting for me at the end of this ordeal. I soon learned that certain color combinations sold fast. I started making more of those. Sometimes a neighbor ordered a pair in certain colors.

It took me a whole, long year to earn the twenty dollars, and my friend's parents would not let me touch the bike until they had the final dime. That's how I learned the value of money and hard work. Two years later, the bike was rusted out beyond repair from the damp weather. I started crying, thinking that I was going to have to go through a similar ordeal to earn another bike. However, my parents showed compassion. They were also, by then, more financially stable.

And I think they found out about the time when I was riding my brother's bike downhill. I was unable to stop it due to faulty brakes, and ended up skirting between lanes of traffic. So, they took me to a bicycle shop to buy my first brand-new bike for which I was incredibly grateful.

Certain guiding forces seemed at work around me as I turned eleven. Sometimes there were emotional upsets in the house. Sometimes it seemed like too much yelling and arguing took place. Or, was I just too sensitive? One day I just couldn't take all the

emotional discord anymore. I ran a mile and a half until I reached the middle of the Driving Park Bridge. I stood there crying while I looked over the stone railing at the rushing Genesee River far below.

I wanted to kill myself.

As I cried, I considered different scenarios. If I jumped and survived, I could disable myself and might have to be taken care of by my parents for the rest of my life. I would suffer even more. I would forever burden my parents. The Catholic Church proclaimed that if I killed myself, I'd automatically go to hell. Well, that was a scary thought. But I also thought that life on earth is a type of hell, with all its trials and tribulations. I wondered if I died, could my spirit perhaps be reborn as a starving child in Africa, or in some other country? Maybe my situation could be worse. As I stared at the river below, its rushing waters became a metaphor for the movement of life. I decided I would study diligently, get good grades, and find out if it was possible to skip twelfth grade. That way, I could leave home and be on my own, one year early.

Around this same time, on one very snowy day, I offered to shovel the driveway before my stepfather got home from work, so he could pull into the driveway. At one point, I took a break and leaned my chin on the shovel's metal handgrip. Suddenly I slipped, and as I grabbed for the shovel to stabilize me, it hit me in the chin. My lower face swelled up. Four weeks later, my entire face swelled and it was difficult for me to talk. I told Mom that the shovel hit my teeth and mouth. She took me to a doctor who said that I might have a tumor and gave me drugs to make the swelling go away. My face swelled up even more, so the doctor decided to operate. He cut open on the inside of the lower part of my mouth and cleaned the poison out of my chin area. After he operated, the swelling went down for a month and then it came back again.

The second time I was in the hospital, I prayed to God to help me. I offered him a deal. "Please God, Sweet Lord of the Universe, I said, "if you help me over this pain, I'll give a gift to the world." Soon I was back home.

19

A few months after the second operation, entailing the exact same procedure as the first, the swelling returned. All along the way, I had told the doctors and my mother that my teeth hurt from when the shovel handle had hit them.

Finally, my mother said, "I'm going to find a dental surgeon for you."

The dentist tested my teeth and found that two of my teeth had died when the shovel had struck them.

"I need to do two root canals and drain the poison from your face," he said. "Then you'll be good as new. You know, young lady, you could have died from having that poison in your face for such a long time."

"Well, I'm glad that you're helping me. But I'm mad at those doctors who were too stupid to listen to me and needlessly gave me those operations."

From that painful horrid experience, I decided that I was not going to trust any more doctors. *I'm going to find a way to take care of myself*, I thought. *Thank you God, for helping me.*

<div align="center">Ψ</div>

Sneaking Out, Skipping School, and Still No Art

Meanwhile, in the new neighborhood, I organized a group of girlfriends and we made up dance routines to perform at local dances. My parents told me that I couldn't go to dances until I was thirteen. Unfortunately, I was eleven and anxious to dance. So, I started sneaking off to meet up with my friends at the dances.

My friend, Nancy called me. "Irene, are you going to make it to the Driving Park Dance? It's going to be a great band."

"I'll be an hour late," I said. "My parents go grocery shopping on Friday nights. After they bring home the groceries, they usually go to a movie and dinner. That's when I can leave the house. I'll see you later."

Sure enough that evening my Mom said, "Irene, we're going out. Are you sure you'll be okay, all alone here?"

"Yes, Mom, you know I like watching *The Twilight Zone.*"

Off they went. Off I went. I bubbled with energy. I ran a mile or so to get to the dance, danced for an hour, and then raced back home before my parents returned. My next in line sibling, Ruth, was five years older than I. She often was at the same dances, keeping somewhat of a watchful eye on me.

When I entered junior high school, in order to keep up my grades, sometimes I asked my mom if I could skip school and stay home to study for a test that would take place that afternoon or the next day. We had an understanding because when I was in eighth grade, I skipped school twice, conspiring with girlfriends. It was a bit innocent in that we went to Adrian's house so we could bake a cake and eat it. The second time we skipped classes, we went to Monica's home to watch soap operas.

However, the high school principal, Miss Truly discovered us kids missing and called my parents. By time I made it home, my stepfather was fuming mad. He beat me with his belt and bruised me pretty bad. Plus, for a whole month, I was not allowed to talk on the phone or leave the house, except for school.

Then I was caught skipping school again. Ruth bumped into me in the high school hallway and said, "Look Irene, I just saved your butt. I overheard Mrs. Truly saying she was ready to send you off to Jefferson High School. I begged the principal not to expel you from school or to notify our parents. I told her I would talk to you. You don't have any more chances."

"Okay," I said. "I won't skip classes again. I promise. Are you sure she won't call Mom? Otherwise, I'm leaving town. I'm not going to let Frank hit me again."

"She said she wouldn't call them. Now go to your next class."

Ruth must have told mom because that's when mom told me that if I wanted to skip school, I needed to stay home and she would call in for me. Between being sick and needing study time, I usually missed more than the maximum days allowed by the school system. I was often reminded how Ruth got awards for never missing a day of school and for being punctual. I loved learning, though, and this strategy helped me maintain my high grades.

Although, I had a burning desire to take art in high school, events again prevented me from doing so. The school had a hierarchal class system. I was in honors' classes because I excelled in math and science. From eighth to tenth grade, I kept asking my guidance counselor to let me take an art class, and he kept telling me that if I wanted to go to college, I needed to stay completely focused on math and science classes. I asked him if I could skip study hall and take art. He told me that only stupid people studied art. This comment put a lot of my friends in that "stupid" category, so his judgmental statement was very disturbing and perplexing to me. I never liked talking to counselors after that time.

My reputation from grammar school as a bit of a heroine had carried over into high school. I was well liked, but fierce enough for bullies to stay clear. When I saw other kids being shunned, I sometimes sat with them for lunch, bringing them into my circle of regular friends.

<div align="center">Ψ</div>

My God is Love. What is Power?

Over the years I carried a quiet resentment from some of my first religious instruction classes. I remember a priest telling us about the different miracles that Christ performed,

which put me in a state of awe. I raised my hand and blurted out, "I want to be like Christ when I grow up."

He said, "You can be a nun and pray to Christ, but you won't be able to perform miracles and heal people. Only Christ, the son of God can do that."

I asked, "What do nuns do?"

"Nuns," he said, "take care of the church, teach classes, pray, and support the activities of the priests."

I asked, "What do the priests do?"

When he got to the part where he said that the priests talked to God for us followers, I said, "I want to be a priest."

I could see that he was flustered, but I didn't quite understand why. "Young lady," he said in an octave louder, "you are a girl and you can only be a nun. Now let me continue with your religious studies." This didn't feel right to me. I was feeling some of my first twinges of societal rebelliousness.

During tenth grade on Wednesday evenings after dinner, I went to religious instructions held at the Sacred Heart School across the street from the Catholic Church, Sacred Heart Cathedral.

Bob, an instructor said, "Only people baptized Catholic will go to Heaven when they die. All the other souls will be lost or go somewhere else, like hell."

I raised my hand, "You mean to tell me that my Protestant friends who are loving and kind will go to Hell, and a person who is Catholic and has committed a horrible crime, but has confessed to a priest will go to Heaven?"

"Yes, that is so," Bob replied. The instructor went on to explain why that was so. I was incensed; therefore I contemplated this for the next few days.

During the next class, instructor Bob read from the bible about how God punished the people with floods, fire and brimstone. It was frightening. I looked around the room and all

the students looked scared. Usually, I was a quiet student, at least until I felt either enthused or provoked.

I raised my hand and blurted out with authority, "My God is all loving and kind. He is forgiving. He doesn't hurt people. I think that men hurt each other. I think that their bad thoughts created the storms, floods and fires."

The instructor's glare silenced me and the other students. He continued reading from the bible and said, "This is the way it is."

When he dismissed class, I strayed behind the other students on the stairway.

Before I could say a word, Bob said, "Young lady, I don't want you coming back to instructions. You're too disruptive."

I said, "I have to come here or my stepfather will beat me." A thought quickly flashed though my mind. *Frank believes that he'll go to hell if I'm not some perfect form of Catholic, but I couldn't tell this man that.* I spoke up, "I have to come. I'll just come and sit quietly. I won't speak during your class." He looked at me in disgust and left.

I was feeling in a quandary. As he drove off in his car, the scattered students all came over to me and hugged me, "Irene, we like your God. God is Love."

After this religious instruction experience, I felt extremely rebellious. I was becoming aware of so many unjust inequalities around me and in the world. I was ready to lead a revolution.

In my tenth grade history class, the teacher told us about the Crusades.

I raised my hand while saying, "You mean to tell me that people killed each other in the name of God? The Catholic Church ordained this act. How is this possible? People fight over a belief?"

The teacher said, "They fight for power over the people, land, beliefs, and gold." Even though this event happened many years ago, it added further to my dismay with the Catholic Church.

In the course, we learned of the many factors of world wars. I asked about some of the modern day revolutionaries. He told us stories.

He said, "Many revolutionaries start out with the idea that they want to help their people and get rid of injustices. But most of the time, once they get into the place of power and riches, they forget their promises. They loose touch with their original ideas. Or the structure of their country is so messed up from the fighting, that it's too hard to implement their ideas."

He went on to say, "One of the great things about the United States is that our constitution and the structure of our country provides ways for us to make changes from within the system."

His teachings profoundly affected me. I talked with God. I prayed, "Please don't let me have power until my heart is pure enough to care for the needs of others." On that day, I chose not to become an outright rebel.

Ψ

Early Love and Adventure

On that destined night, a white haired, blue-eyed sixteen-year-old boy asked me to dance. I was fourteen. Being a blonde with blue eyes, I was attracted to dark haired boys with dark sparkling eyes. But, Karl asked me to dance. As we danced, dance after dance, I loved exchanging flirtatious moves and how we expressed ourselves differently with each song.

The slow moving dances scared me. New feelings were being aroused in my body. His heartbeat pounding so close to mine caused my heartbeat to go into sync with his heartbeat, causing a feeling of merging together. His warm breath caressing my neck put me into a trance. Simultaneously, all the warnings of civilization popped into my head saying,

"Protect yourself, Irene." It was too late, as I had already melted into Karl and he into me. All too soon, the music stopped, the lights came on and I came to my senses.

As I'm thinking about what the heck just happened to me, Karl flashing me a smile asked, "Irene, can I give you a ride home on my motorcycle?"

Feeling sad, I said, "I have to ride home with my friends."

Thinking fast, Karl asked, "Are you free tomorrow? I'm going to Letchworth State Park with friends. We can go swimming and hiking there."

"Wow, that sounds like fun. You'll have to pick me up at least 5 blocks from home. My parents would never allow me to go on a motorcycle."

"Let's exchange phone numbers," we said in unison and then laughed.

"Karl, I'll call you when my mom isn't around to listen."

"Try to call me between 9 a.m. and 10 a.m.," he said.

"Alright," I said.

"I sure had fun dancing with you tonight," he said.

"Me, too." I have to go now. Bye."

"See you."

The next morning, I met Karl at our designated location. He handed me a motorcycle helmet to put on and showed me how to wrap my arms around his waist.

"I have to be back by six o'clock," I said, as Karl revved up his cycle's motor.

He agreed to my time schedule. Karl's friend, Hat, also drove a Yamaha motorcycle. Hat introduced me to his girlfriend, Carol. Excitedly, we drove the fifty miles to the state park.

Upon arriving, we agreed that swimming was to be our first activity because of the hot humid heat bearing down on us.

As I put on my bikini in the locker room, I told Carol, "That song keeps singing in my head about a girl who was afraid to come out of the locker. I feel just like her. I am so embarrassed in this skimpy swimsuit."

Carol giggled and said, "I feel shy, also."

I ran out and jumped into the pool. That first burst of shyness subsided and was replaced with new sensuous feelings as Karl's wet body gently slid by my wet body in the cool blue water. We laughed so easily as we played games.

After swimming, we ate lunch. Then we found a hiking trail filled with colorful bushes and a variety of trees. Our trudging over fallen branches and leaves sent earthly smells into the air mingling with the scent of pine that was suspended in the humid air. We walked for a half hour, and then Karl suddenly stopped. My body bumped into his. Karl put his arm around me. As Karl gently pressed his lips against my lips, a tingling vibration set my body ablaze with a youthful passion. I was in unknown territory. My senses were heightened. I delighted in the enhanced sounds of the birds singing and the bees buzzing. As the sunlight peaked through the tree braches, I felt its sensuous warmth dancing on my face. As Karl's lips heated my lips, the gentle breeze cooled my lips. Memories of sensations from eating a hot fudge sundae filled my head. I loved the warm delicious taste of the hot fudge warming my mouth as the sweet ice cream cooled my tongue. The breeze blew through my hair feeling like loving caresses. As Karl's body pressed into mine, the tree behind me pushed my body into his; I felt as though all of nature was conspiring to arouse me.

Such were my youthful years spent making love with Karl in caves made of green leaved bushes. It was a secret that I held dear to me, as I daydreamed high school away.

During my entire tenth year of high school, Karl, Hat, Carol, and I plotted to run away into the wilderness of the Canadian Rockies. We had a car, a motorcycle, and all kinds of supplies. Karl wanted to leave just as final exams were coming up. I wanted to leave after the exams. We left before.

On our first night up in Canada, we set up our tent next to a river. All night long, tiny black flies kept biting us. Not knowing what these tiny little bugs were put us in a state of high anxiety. The sound of the rain beating upon our tent felt threatening. Waves of cold shivers shot up my spine. From exhaustion, I finally fell asleep. During the night the river

swelled over its sides. Upon waking, we found ourselves to be wet and our car's tires had sunk down to the axles into the mud. Fortunately, we found a farmer with a tractor to pull our car from the mud.

His face filled with a concerned look as he sized up the situation.

He said, "I don't think that you kids have much camping experience. I want to warn you that the Moose are in their mating season; so don't camp near any Moose. They can look docile, but can be very ferocious."

I figured that there were a lot of unknowns in nature waiting for us. I was studying my pre-exam books all the way, just in case we got caught. Next, the motorcycle broke down and we had to tow it. The police stopped us, but let us go.

A little while later, the same police stopped us and asked, "Do you kids have any weapons in your car?"

Karl said, "Yes we have two riffles. We're going camping in the Canadian Rockies and we'll need them for protection."

Then the policeman said, "Well, you need to follow us to the jail house so we can talk with you."

We were all trying to hide our fear as we drove toward the jailhouse. The jailhouse was a small building with an office and two small barred rooms, which made it less threatening than a larger facility. Upon seeing us, the Sherriff separated us and questioned us individually. I was the first to be questioned.

"What are you doing up here in Canada?" He asked.

"We are headed to the Canadian Rockies. We want to live in Nature. Our society has fallen apart. Lots of young people are taking drugs. The air and water is so polluted."

"Why do you have guns with you?"

"Well, if we live in nature, we may run into a mountain lion or a grizzly bear."

"How were you planning on eating?"

"We have fishing poles. We have a bunch of packets of vegetable seeds."

"How long have you been planning this trip?

"For about a year and a half."

"How do you feel about black people?"

"I like black people . . . that's a weird question," looking perplexed as I answered.

Now he looked perplexed as his eyes softened, he replied, "I need to question the others. Then I'll decide what I'm going to do with you kids."

He questioned the others and then sat us around his desk. "I'm in conversation with your parents and the Federal Bureau of Investigation, right now."

We snuck glances of fear to each other.

My mouth dropped open and I questioned, "FBI?"

The sheriff ignored me, saying, "It's getting late, I'm going to order you kids some burgers and fries. Meanwhile, you girls share that jail cell. The boys get to sleep in the other cell."

As his key jangled in the iron lock, I felt alarmed. "Carol," I whispered. "I really don't know what we did that's so wrong that they called the FBI."

Carol looked dazed as if she were in shock. I felt sad for her, but I wanted to size up the situation. I looked around our tiny cell with its two tiny cots without sheets and the toilet with no paper.

I stuck my face against the cold steel bars, politely asking, "Sir, do you have any blankets and toilet paper?"

"This is not a hotel, young lady," he replied gruffly. As I raised my eyebrows, I could see that he was trying to hold back a smile. Then softening a bit, he said, "My wife is bringing over some sheets and blankets. And she'll probably bring toilet paper. She has a sweet spot for kids."

Finally the burgers and fries arrived. The fries came with vinegar on them instead of catsup. I thought, *now they really are punishing us*. Somehow, I managed to eat them.

As it got dark, the sheriff said, "I'm going home now. Don't worry, if there is a fire, the alarm will go off. I live nearby."

$$\Psi$$

Grounded: Followed by Love and Heartbreak

The next morning, the sheriff showed up bright and early. "Breakfast is here," he announced. "Come sit around my desk while you eat." He unlocked our cell doors.

As we sat in chairs around his desk, the sheriff looked at Karl and said, "Apparently, your Mother got desperate about finding you. No one would help her. So she called the FBI and said that you had guns and went to Canada to incite riots. The FBI put an all points bulletin out on you kids. I just called the FBI and told them that you're nice kids and that you were running away to nature. As far as I am concerned, you're released."

We looked at each other breathing out sighs of relief. I wasn't the only one holding my breath.

"However," he continued, "Karl's aunt and uncle started driving up here last night to escort you back home. They want to make sure that you stay put. And all your parents are in agreement on that matter."

Karl's aunt and uncle arrived late that morning. His uncle drove our car with the boys. And his aunt drove Carol and me. When we arrived back in Rochester, our parents all thought of different ways to punish us. I couldn't see or talk to Karl for a month. I could only leave the house for school or work.

I had missed two of my exams. My mom called the high school to see if I could still make up my exams. They let me take them in a room with my biology teacher, Mr. Abernathy as the proctor.

After I finished the exams, Mr. Abernathy said, "If you wait a few minutes, I'll tell you your score and grade for your biology class."

"I think I did alright."

After a few minutes of looking at me quizzically, Mr. Abernathy said, "So, Irene, your sister Ruth told me that you ran away to Canada. How did you mange to pull off getting a B plus on your Biology exam?"

"I got a B plus!" I exclaimed. "So when you average all the tests together, I'll still have an A average. What a relief."

"That sounds about right," he said. "So how did you manage to get this score?"

"I studied along the drive just in case we got caught."

His forehead wrinkled like he was surprised, then a slight smile appeared and he asked, "Do you want to tell me why you ran away?"

"My friends and I felt that our society is so corrupt," I said, "and there's so much pollution and drugs that we wanted to run off and live in nature. We were headed to the Canadian Rockies."

"Well, I must say that I admire you and your friends," Mr. Abernathy said, "I know of young people running away to New York City and getting in trouble, but not running away to nature. Irene, continue your education, then you'll be able to choose where you want to live. You'll be prepared."

Wow, he had been a strict teacher and I had won his respect. I felt good.

At sixteen, I started working several nights a week and on weekends in order to save money for this place called college. My parents were happy I was so eager to work. And when time permitted, I was still able to fit in dances.

I was studying toward graduating high school a year early. I had planned since ninth grade to get enough credits and go to summer school for twelfth grade English class. Originally, Karl and I were following in the footsteps of his aunt and uncle, who were both chiropractors. They taught us about keeping healthy through food, herbs, vitamins and

positive thinking. They taught us about the side effects of drugs and medicine. They shared with us their philosophies of the different religions they had explored. I admired them and was so grateful for their influences upon my life.

Two years ahead of me, Karl left for Palmer Chiropractic College in Davenport, Iowa. After a few months, I sensed Karl pulling away. His letters hinted he no longer needed me. I felt a lover's pain, "He loves me. He loves me not." When I told him that I had the strength to reach for the stars, to achieve my goals, and to be a millionaire without him, he once again proclaimed his love for me. He admired my independent determination. Yet, when he came home from school on spring holiday, he only spared a few days to spend time with me. Before, we had been inseparable. He told me that his uncle needed him to do work. I felt rejected.

As fate would have it, I met Kurt at the local soda fountain. The owner, Wallace, always introduced the people sitting at the counter by telling little antidotal stories about us. Invariably, we would laugh and bond. Anytime I felt sad, I knew that one of Wallace's Cherry Cokes and specially cooked burgers would cheer me up. He would warm the buns on the grill along with the burger, and then put the catsup, mustard and pickle on top of the burger just to heat it slightly as the burger finished cooking. My mouth watered from the smells, the sizzling sounds, and the visual beauty of the burger on the grill.

On such a day, Wallace introduced me to Kurt. Instantly we were laughing and talking. Kurt was so intelligent and I really enjoyed his company.

Kurt asked me, "Would you like to go to a dinner and a movie with me on Saturday?"

"I kind of have a boyfriend."

"What does that mean?"

"Well, he's in Iowa going to college. We're supposed to get married. But, he just wrote me and suggested that we date other people to make sure. He's breaking my heart," I said. My stomach began to hurt. I was trying to hold back my tears.

"It sounds like you need a date. You can write him a letter about what a good time you had on the date that he suggested."

Wallace chimed in, "Go have some fun, Irene."

I didn't think it was possible, but I began to enjoy Kurt's friendship. I wrote Karl explaining that I may have a new boyfriend. Of course, he wrote back that he didn't mean what he previously wrote me. He said he'd be home in a month for summer vacation and that we needed to see each other no matter what. I agreed to go on one date with him to see what he had to say.

For our date, Karl and I went on a picnic at the park.

Angrily, Karl said, "We need to talk, before I'm going to see you again."

"Yes we do," I said. "And what makes you think I'll see you again?"

"Did you sleep with this guy?"

"Why should I tell you anything? You broke my heart pushing me away. Tell me why you didn't have time for me over the holidays?"

"My aunt and uncle offered me their convertible car, on condition that I date their friends' daughters when I came home on the holidays. You know how much I wanted that car. Also, they gave me money to take other girls on dates while I was at college. They said they preferred I marry one of their wealthy friends' daughters."

Feeling stunned and sick to my stomach, I cried, "Wow, I guess you made your choice. It's hard for me to think that I admired your aunt and uncle. I feel so deceived." I thought, *no wonder, I had felt so much pain.*

Karl replied, "I only want to know if you slept with this new guy?"

"His name is Kurt and yes, I did make love with him."

"Don't think that I'm going to date you," Karl said, as he grabbed and kissed me. "Let's make love one last time."

"What are you, crazy? You hurt me and then you want to make love to me," I screamed, while pushing him away from me.

He started crying and said, "Look, I'm sorry. Let's eat our food. We can talk for a while."

While we ate our sandwiches, we talked about the fun we had during our four years together.

"Do you remember my high school party at the beach?" he said.

"Sure, you had a lot of nice friends."

"Do you remember me asking if you thought a girl was pretty?"

"Sure, I thought she was pretty, but I also thought that was a strange question. But I trusted you."

"I had liked her, even before I met you. After the beach party, I asked her for a date. We went to the movies. She wouldn't date me again. So I poured a glass of juice over her head. I got detention for it."

Emphasizing each word I said, "You dated another girl, while we were together. Are you making this up and just trying to get even?"

"No, I dated her. She wasn't so special."

"So, you cheated on me even without your aunt and uncle instigating it?"

"I didn't sleep with anyone else," he replied as he glared at me.

I just sat there quietly, feeling shocked. This last bit of news sent my mind in swirls. Where else might he have deceived me? Our relationship was truly over. I could never be with this man again. He seemed heartless.

"Karl, you might as well drive me home," I said. "At least we're clear that our relationship is over.

Chapter Two

First Taste of Independence

Ψ

Leaving The Nest: More Heartbreak

*O*f course my mom was upset when I said to her, "Mom I'm leaving home with Kurt. We're headed to Kansas."

She said, "Irene you're only seventeen. I can stop you from going since you're a minor. Besides, I don't want you to leave with Kurt. He is 26 years old. He's too old for you. I can have him arrested."

I said, "Mom, I'm going to sign up for Highland Jr. College, in Highland, Kansas. Kurt is going there to finish college."

"I just don't want you to go," Mom said.

I became frustrated. "If you make me stay here until I am eighteen years old, I'll leave and you'll never hear from me again. If you let me leave, I'll write you once a week and call you long distance once a month."

She started crying as she saw that familiar look of determination on my face. She relented, "If you sign up for college right away, I guess it's okay for you to leave."

I felt bad that I made my mom cry, but it was time for me to leave. I gave her a hug and thanked her for understanding.

Shortly thereafter, Kurt and I drove to Missouri. The trip was depressing, scary and exciting all at the same time. Upon arrival, I had two hurdles to overcome. First I had to

take the SAT exam at the new college. I passed math and science with very high scores. However, I didn't fare well on the English section. I told the counselor that I had a mental block when it came to English.

I said, "I averaged B's in high school English. Just let me into the college, I'll pass English, and then your needs will be met. If I don't pass, you can throw me out."

"We have another problem," the counselor said. "We don't have any dorm space left. You are only seventeen years old and we feel responsible for you."

"I've already rented an apartment in Saint Joseph, MO. Even though I'm 17, my mother let me go on the premise that you would let me into college. I can have her write you a letter."

That semester, I started Highland Junior College. The college building was smaller than my high school building. Highland Kansas was so tiny; there was a joke that the words "Entering Highland" and "Leaving Highland" were printed on the same street sign. My grades were easily good enough for their Honor System. I loved learning.

Kurt and I found an apartment that was part of an elderly couple's home. It was built over their garage. After school, doing homework, and eating dinner, I especially enjoyed the routine of watching the night show and then making love. Often he would bring out a large colorful tin box and give us each two homemade chocolate chip cookies. He would smile and say that his grandmother sure knew how to bake good cookies. He always got the mail from the mailbox. He seemed to get a lot of letters from his mom and grandmother.

After a few months, we developed some friends at the college, Bob and Jill. Up until then, I had felt rather lonely, missing my friends. The four of us would eat together on our lunch breaks, have intellectual conversations and laugh a lot. One night, Kurt and I invited them to go to a movie with us. They drove about 15 miles to get to our apartment that evening.

When they arrived, I greeted them and said, "Kurt hasn't come home from work, yet. I'm a bit concerned because he needs to park his Volkswagen Van on a hill in order to start it. It may have broken down." I doubted my own words.

Jill said, "There's a second showing for the movie. We'll talk for a while and if he doesn't show up, we'll go ahead. You could go with us."

"Oh, no, I need to stay here in case he needs my help."

We talked and laughed. Kurt was a no show. They went off to see the movie.

It began to look like he wasn't coming home. I suspected that he might be out with another girl. I cried.

I went through his dresser draws in order to see the letters his grandmother had supposedly wrote him. Instead, I found juicy love letters written by his wife. In one letter, she said that she was looking forward to him coming home for Christmas and spending time with her. He had told me their divorce was almost final. His relationships were all lies and deceptions. He told me that his grandmother had been sending him homemade chocolate chip cookies. I'd been eating cookies baked by his wife. *Oh, my God!*

I went into shock. I sat in the cold empty bathtub, crying, every past love wound reopened. Around four in the morning, he came back. After I badgered him with questions, he admitted that he'd been out with another girl. All in one fell swoop, he had dishonored our new friends and me. He once whispered under his breath that he was a bastard. I made a note to remember that if someone proclaims something bad about oneself, it just may be true. I had admired his intelligence, but I learned that an intelligent person doesn't necessarily have morals.

Within a week, I found my own little apartment for fifty dollars a month. It had a Murphy bed, the kind with a strong spring that pulls it upright into the wall. There was hardly room to stand while the bed was down, so I decided to tackle this massive steel monster. I gripped the steel bottom end of the bed and pushed up with all of my might, when all of a sudden the bed flew upright into the wall with me dangling in the air. After

the shock subsided, I let go and fell to the floor. Replaying the scene in my head, I started laughing. It was like a scene out of an "I Love Lucy" episode. I decided to ask a friend to pull the bed back out of the wall for me. I left it down.

It was lonely having my own little apartment, but I started getting used to it. I still needed a ride to the college from Kurt, so I did my best not to think about our broken relationship. I often cried when he dropped me off at my apartment. I still liked him, but I knew he was wrong for me.

As Christmas break neared, I was having lunch in the college cafeteria with Kurt, Bill, Jill and Clarissa. Clarissa was one of the few black girls in my classes. We had become lunch buddies.

Excitedly, Jill said, "Bill and I are going to visit our family for Christmas break. Then we're all going skiing together. It'll be a relief to get away from this tiny town."

Looking forlorn, Clarissa said, "I'm stuck here. And there 's hardly a soul that's going to be left in this little town."

Filled with empathy, I said, "I know how you feel. I ate my Thanksgiving lunch at some lunch counter in a restaurant, all alone. Now I'm alone again for Christmas."

Bill chirped, "Hey, you two ought to spend Christmas together."

My spirits lifted. "Clarissa, I have my own little apartment. You could sleep on my couch. We could spend Christmas and a few days together over the break."

Clarissa's eyes sparkled. "Really?"

We jumped up and started hugging each other. We didn't have to be alone. Everyone at the table looked happier.

It was a small building I lived in. While looking as if it may have been a great Mansion at conception, the building had since been divided into apartments. My kitchen was a narrow room across the hall from my apartment. I felt squashed and a wanting for air. The only redeeming value was the low rent.

The landlady did not allow me to have a man as an overnight guest, so I asked her permission to have a female friend from college come stay with me for the holiday.

Martha, the landlady said, "I'm glad that you won't be alone this Christmas. Remember, though, no boys in your room."

Clarissa showed up two days before Christmas. We went to a movie one day and roller-skated the next day. We shared our life's stories, laughing a lot.

Then came the pounding knock at the door.

An angry voice blurted, "Irene, this is Martha, I need to have a word with you!"

Stunned, I opened the door. Martha motioned for me to come down the hallway. I followed her.

"You have to make your friend leave, right now!" Martha said. Her angry voice projected sound images of arrows aimed at my heart.

"You gave me permission. Did you forget?"

"You did not tell me . . . she was a Negro. I don't want Negroes in my building. You make her leave right now, or you need to vacate your apartment at the end of this month, young lady."

"But tomorrow is Christmas. Where will she go? What am I going to say to her?"

"I don't care what you say. She has to go now."

Shocked at Martha's prejudice, I backed away from her, tears streaming down my face. She huffed, turned around, and stormed down the stairs. Christmas didn't matter anymore. I was scared for Clarissa. I walked back into the room.

Clarissa cried as she put clothes into her suitcase, "I heard that woman, Irene. I'm going. I'm not going to let you lose your apartment."

"Look, I no longer want to stay in this building. I'll look for a new apartment right after Christmas. Stay with me for Christmas, Clarissa."

"I looked at the bus schedule while that lady was yelling. If I hurry, I can make it to the bus."

"Okay, Clarissa . . . I'll walk with you to the bus stop. I'll wait with you. I'm so sorry; I had no idea that the landlady was so prejudiced. She claimed to be so religious . . . so Christian. Christ wanted people to love each other. People just don't get it."

As we walked to the bus stop, we both started giggling.

Wiping my tears, I said, "At least we had two days of fun, before the witch appeared."

"I was thinking the same thing," Clarissa said. "We did have fun."

As I walked up the two flights of stairs to my apartment, I felt more alone than ever before. Once again I was alone for the holiday. I started packing some of my clothes, lost in thought. *So much cruelty persisted in this world. Why?*

<div align="center">Ψ</div>

The Universe Responds Fast

There was a knock at the door.

"Who is it?" I asked with a bit of anger, thinking it might be Martha.

"It's your neighbor, Jan."

I had seen her in passing with her boyfriend, but we had never spoken. What could she want? I wondered.

I opened my door. "Hi Jan, What's up?"

"My boyfriend, Tim and I overheard the landlord. We're moving into a big apartment on January first, but we need a roommate. We'll give you the biggest room with a window and you'll only have to pay $45.00 per month. It's a nicer neighborhood. Come on over to my apartment. We can drink some soda and you can meet Tim."

Surprised by the sudden turn of events, I said, "Okay, just let me lock my door."

We shared stories and talked until late into the night. They invited me to have lunch with them for Christmas and to spend the rest of day with them. I agreed. I figured it would give me time to see if I should or could share an apartment with them.

The next morning, I called Clarissa and wished her a Merry Christmas. She told me that one of her brothers was picking her up and that she was going to spend time with her family, after all. I told her about my possible new apartment and friends.

Later that morning, Jan came by my apartment. "Hey Irene, even though it's Christmas, the landlady of the other apartment said we could show it to you."

"Sounds great. Let's go."

My bedroom room was big, with a huge window that overlooked a quiet tree-lined neighborhood street. The location of my room would give me privacy. The kitchen was large.

"So, what do you think?" Jan said.

"I wish we could move today."

"The landlady said since it's vacant, she'll let us move in tomorrow, if we want. Let's go celebrate."

My first night lying awake in my new room, I contemplated these quick turns of events. I remembered a thought I had during my sophomore year in high school, and I reaffirmed it: "God, please help my heart to be pure. Please give me power only when my heart is pure . . . pure to care deeply about all peoples."

During that week, I discovered that Missouri Western University, a four-year university was located in Saint Joseph. I promptly enrolled and was accepted immediately. I continued working night shifts in a restaurant called 'Snow White' to support my college and living expenses.

I called Clarissa and told her that I wouldn't be coming back to Highland Junior College and I would miss our lunches together. She said that we ought to keep in touch and I agreed.

Although a chemistry major, I found myself amidst many artists and musicians, who had made the arts their academic subject of focus. This surprised me, remembering as I did, the discouragement of my high school counselor.

The new university had lots of cute young men. Looking at them helped me overcome my disappointment in the opposite sex. After having my heart broken twice in a year's time, I decided to date very casually. After a year, however I realized the emptiness of endless dating. I needed depth. I needed intimacy.

Ψ

Hitchhiking Home and Taking More Risks

During Easter break, I didn't have enough money for a round trip airplane ticket to Rochester, so I hitchhiked home. I was a bit scared, but I had often seen young people hitchhiking along the roads. As a precaution, I dressed myself to look like a little boy, not realizing that little boys could also get into trouble. I braided and tied my waist length blonde hair up and tucked it under a baseball cap. I wore my brother's old sweater that was a few sizes too big for me. For protection, I hid a small container of mace in one pocket and one of my dad's hunting knives in my other pocket.

My first ride out of St. Joseph was with a group of three men from the Ozarks in Arkansas.

When I got into the car, one man said, "Where are you headed young man?"

I said, "I miss my family and I am headed to Rochester, New York."

He stared at me.

"Why, you aren't a little boy. Anyway, we can take you as far as Kansa City."

"I dressed this way for my safety."

"Well, it was probably a good thing to do."

These men looked like hillbillies that I'd seen on TV. I thought to myself, *I better not let them know I'm in college. They might think that I'm uppity."*

I said, "I've never been to the Ozarks. What's it like? Does your family all live there?"

They were kind to me as they told their stories and left me off at a good spot along the highway where I could catch my next ride.

My next ride was with Larry. He explained that he was home on leave from the Viet Nam War.

He said, "I like the war. I'm getting rich from stealing car parts that the army sends over to Viet Nam. I'm buying my mom a house."

"Aren't you scared with all the fighting?" I interjected.

"Hell no, I like killing those gooks. Can you imagine that the government pays me to kill them?"

I was *scared as shit*, but maintained a poker face.

"How many more times do you have to go back?"

"Gotta go back for a few more years."

"Well, I sure do admire your bravery and I appreciate the ride." When he dropped me off at another hitchhiking point, I took a deep breath and said, "Thank you, God. I don't know what I've gotten myself into, and I'm sure hoping that I'm going to get home safely."

Of course, I was hoping the next ride would get me all the way to Saint Louis, Missouri. Soon a car stopped. It had three businessmen in it.

The driver said, "We're on our way to St Louis, Missouri."

I said, "I want to go to the airport." There are usually so many young people flying standby and stranded for a few days that I'll be able to sleep there without anyone harassing me.

They introduced themselves.

Bill the driver said, "Why don't you fly to Rochester?"

"I only have enough money for a one way ticket. I figure it is best to fly back so I can get back to college on time"

Bill responded, "I can get you close to the airport, but not to it."

They told me stories about their sales jobs and how they were headed to a convention. They were relatively nice until we got close to St Louis, and the sun started to set.

Then John said, "Being a college girl, Irene, do you like to party?"

Acting stupid, I replied, "Not really, I'm too busy working and studying."

Then Bob said, "Why stay at the airport? You can stay in our room and party with us. In the morning, we'll drive you to the airport and buy you a ticket to Rochester. We'll show you a good time."

"It's kind of you to offer, but I really don't want to party. Changing the subject, I asked, "Bill, do you have any kids?"

Proudly, Bill said, "I have a daughter, she's eighteen."

"My age."

I looked him in the eye through the rear view mirror. "Bill, would you want some man to proposition your daughter and ask her to party?"

He appeared to get angry.

He said, "No, and I wouldn't let my daughter hitchhike. I'd make sure that she had a ticket to fly home."

"Well, your daughter is lucky to have a father that can help her."

They quit asking me to party with them.

It was 10 p.m. when Bill dropped me off at a downtown spot. He said it was a few blocks to a bus station, where I could get a ride to the airport. It was a ghetto and a red light district. Drunks lay propped against buildings.

I saw an old black man who appeared normal. I asked him how to get to the bus station.

He pointed. "It's two blocks down that way and to the left. You don't belong in this neighborhood. This is one bad neighborhood."

I ran full throttle to the bus station. Inside was scarier than outside. I quickly found out that there weren't any more buses leaving for the airport. I went to the bathroom and it looked like a few women were doing drugs. I knew I couldn't sleep in the bus station.

I felt like my life was on the line whether I was inside or outside. I asked a bus driver for directions to the airport. He told me and I took off.

Three blocks from the bus station, I saw a huge six-wheeler truck. I waved and stuck out my thumb. He pulled his truck over to the curb. I climbed up into the cab.

"I'm trying to get to the airport. I'd be really grateful if you just get me out of this neighborhood."

"I just happen to be passing by the airport. I'll be happy to drop you off there. What airline?"

So tired, I barely spoke the words, "American Airlines."

Once I was in the airport, I found a safe chair in which to sleep. In the morning, I ate a pastry and drank hot chocolate for breakfast. For a moment, the world was a safe place.

I went outside the airport with my little overnight bag I'd packed with an extra pair of jeans, some underwear, socks, two sweaters, and toiletries. I asked a taxi driver for directions to the correct highway going east. Then I walked to that entrance. A few hitchhikers were already there, mostly young people and army vets. They told me that I might get a longer ride, if I made a sign that says Rochester. They said they were only going to downtown St. Louis, but if someone stopped and had room, then we could ride together for a short way.

The driver that stopped was heading in their direction, but said he would drop me off where I would be heading in the right direction. So far, that felt like my safest ride. They dropped me off and wished me good luck.

Shortly, a big fancy black Lincoln Continental stopped. There were four young black men in fine quality suits.

They asked, "Where are you going?"

"Rochester, New York."

They laughed. The driver said, "Hop in, we'll give you a ride."

"Your car looks pretty full."

"Hop in," the driver said with a tone of command, but with a slight smile. His eyes had a sparkle. I was scared to get in the car, but more scared not to get inside. I hopped into the car and smiled.

"You men sure look nice," I said. "Are you headed to a business meeting?"

They laughed.

"You could say that."

I decided not to talk, unless they talked to me. After we passed about four exits, they dropped me off and wished me luck. Somehow, I felt as though I had just been in a car with the "Black Panthers".

I was grateful it wasn't too cold out. My next ride was with Joe who took me to the edge of New York State. He was a real nice man and talked about his job and family. I felt safe. At one point, he stopped for food. He bought a loaf of bread and some sandwich meat for us. Joe handed me the food.

"Make us some sandwiches, while I drive. That way we won't lose any time. I hope you don't mind this meat. It's my favorite."

I looked at it through the wrapper. It looked pretty weird to me. I read the label. The contents were pig's feet, pig's this and that. I thought, *oh my God, I'm so darn hungry, but do I eat this stuff?*

"Well, if you really like this meat, it must be okay," I said.

I made two sandwiches and watched him take his first bite, making sure that he wasn't playing a joke on me. Sure enough, he relished that sandwich. I managed to get mine down.

I just wanted to make sure it stayed in my tummy. It took away my hunger pains. As the sky darkened near dusk, Joe dropped me off near the New York state line. I was glad to be alive and getting closer to my destination, but the universe sure wasn't encouraging hitchhiking as a way to travel.

At the new hitchhiking spot was a young man, about twenty years old, named Jerry.

Jerry said, "I've been here for three hours and not many cars have gone by. Please let me ride with you, when a car stops? Sometimes at night, a trucker will get you all the way to your destination. Truckers are the best rides."

I was shivering from the cold air. The drizzling rain penetrated my clothes. Behind us, I noticed a little motel.

"Sure," I said, "only if a ride comes in the next half hour, because I don't want to stand out here in the dark and in the rain. I'm going to see if the motel person will give me a room for fifteen dollars. If so, I'm going to take a hot shower and get an early start in the morning."

"That sounds good. I don't have any money. I'm broke right now. I'll have money when I get home and if you let me share the room, I'll send you the money."

Knowing that I might never see the money, I replied, "Sure, I'll share the room. But don't mess with me. Then we can get an early start. I'm tired of hitching alone."

Jerry looked relieved. Just as we made it into the motel room the sky burst open with thundering and lightening. Heavy rain poured down.

The next morning, we didn't have to wait long. I held out my Rochester sign. A huge RV stopped. The driver, Fred said that he was dropping the RV off to a person who lived in Rochester, NY. It was a fun ride. We dropped off Jerry at his destination.

When we arrived at a busy intersection in Rochester, Fred said, "I got you this far young lady, I sure wish I could get you all the way home."

"I really appreciate it. I'm going to find a phone and call a taxi. My parents need to think that I have just flown in on an airplane."

"Here's ten dollars. Promise me you'll take a taxi."

"Wow, thanks Fred. I'll do a good deed for someone else and it'll be from you. I'm so happy I made it home."

<center>Ψ</center>

Short Visit, Then Back to Missouri

I had a fun time visiting with my family and friends. I went dancing and talked with friends late into the night. I was happy to be home. Way too soon, it was time to go back to St. Joseph, Missouri. My parents dropped me off at the airport and I flew standby back to Missouri.

A few months later, just as I was walking out the front door of my apartment, I noticed an old VW Van with a group of young hippie-men pulling up to the curb. A familiar face emerged out of the van.

He yelled, "Hey, Irene, it's me, Jerry. I've come to give you your money, like I said I would. Here's ten bucks for you."

"Thanks. What a surprise. I didn't expect you in person."

"My friends told me that we were going through St Joseph on our way to California. I told them that I had to stop to give you some money. I can't begin to tell you how you saved my life out there. You trusted me enough to share your room."

"Well, you have renewed my faith in human kind," I replied.

"I wish I could talk more, but my friends are anxious to get driving towards California."

"I really can use the money. What a great surprise. Thank you."

Hitchhiking caused me to summon up all my street smarts. My good sense of human psychology protected me. It seemed that I was becoming a risk taker, or, as one who would sneak out of the house to go dancing, was I just upping my risks?

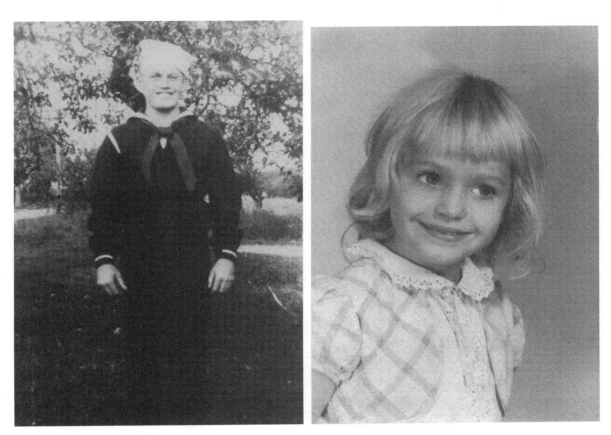

Fig. 1 Left - My father, Edward Vincent, 20 years old

Fig. 2 Right - Irene, 8 years old

Fig. 3 Irene, age 27 & Mom

Fig. 4 My sister - Ruth, niece - Kerri, mom - Violet, Irene

Fig. 5 My brother, Ed

Fig. 6 My sister, Jayne and her husband, Kurt

Fig. 7 Nephews, Bill & John, Irene in center

Ψ

Risky Summer Adventures

The semester at school flew by. Just before summer break I was invited to a party. That evening, I met Mack, an Arab student. I instinctively knew to keep a distance from him; however, we were talking about my favorite subject, traveling.

Mack said, "Irene come visit me in Montreal, Canada on summer break. I'll buy you a ticket there and one to Rochester. No strings attached. I'll show you around Montreal and we can get to know each other."

"It sounds interesting. If I go to see you, I won't sleep with you. I'll think about the trip."

"Call me in a few days and let me know."

Appealing to my spirit of adventure, I called him. "I'll fly to Montreal to visit you for a week."

St. Joseph was a small town and I often bumped into my ex-boyfriend, Kurt. When I told him how I was going to begin my summer break, he exclaimed, "Irene, he might be drawing you to Montreal to sell you for the slave trade."

"God, Kurt, you're crazy! There's no such thing. Slavery doesn't exist anymore. You're just jealous."

"Believe me Irene, it exists! I don't want anything to happen to you. Be careful."

"Now you have me worried and I already have my ticket."

When I got to Montreal, Mack met me at the airport. We stopped by the hotel room, where I left my luggage. He told me we were going to meet his friends for dinner. It was a dark, dingy, little restaurant. It felt off to me. His friends were all men, speaking in Arabic. It put me on alert. I began to think that maybe Kurt was right about that slave market thing. My adrenalin went up and the wheels in my brain started turning.

How am I going to get out of this predicament? Thank God, I'm such a skinny ninety-pound small-breasted teenager, I thought. *Surely, these men won't want me. I'll just stay alert and run for it.*

Dinner ended and we headed back to the hotel. I asked Mack about his plans for the next day. He said he had to go to work in the morning and make some arrangements, and then later in the day he would show me around Montreal. I didn't sleep that night.

The next morning I asked Mack for the promised money for my airplane ticket to Rochester. He told me he would have money in a few days. As soon as he left, I packed into my backpack as many clothes as I could and I walked out. I went to a park where a band was playing music and met a college student named Adam. We discussed college life. I sensed a kindness in him, so I told him about my dilemma.

"I left my suitcase at the hotel because it was too heavy for me to carry around. I just wanted to get out of there. Mack promised me $50.00 for an airplane ticket to Rochester. Now, I am losing my luggage and airplane ticket, because I won't go back there."

"Irene, you can stay with my roommates and me for a few days. I'll show you around Montreal and then it won't seem like such a loss. In fact, we'll go to the hotel and get your belongings."

"I don't want to put you in any danger. I don't know if he has a gun or anything."

"Irene, this will be the right thing to do."

"Promise me that you'll be nice to him, just in case he had no ill intensions," I said.

"I promise you. Come and I'll introduce you to my friends. We'll go by the hotel later today."

Adam not only got my belongings, but he told Mack to give him the money he promised me for my airplane ticket. Mack handed over $50.00 to Adam for me.

When Adam returned, he said, "Mission accomplished. Here's your luggage and money. Mack lied to us at first about promising you anything. He finally said that you were

telling the truth. Anyway, we think that you're right about not being safe with him. You can stay here for as long as you like. I'll take you around Montreal."

I sighed and felt relieved. "I'll stay for about a week. I need to go home and get a job so I can make money to go back to school in the fall."

A few days later, Adam's friends came to stay for a few nights. It was a hippie thing to do. A lot of college students would let friends and other students stay overnight in their apartments. We called it crashing. Everything was peace and love. We were very open to helping one another. We shared stories of life and adventure.

It turned out that these two students; Peter and Gary were staying in a commune in Greenport, Long Island. They were helping to rebuild an old seventy-two foot fishing schooner, the Mary Ogden. They said whoever helped to rebuild her would get to sail on her down the Amazon River. Peter and Gary invited me to join the commune. I told them that I had to go to Rochester first. They offered to give me a ride down to New York in their Volkswagen Van. Then I could catch a bus or train.

Off I went on a new adventure. At the border, the US Customs detained us. First we were strip-searched. They called in a lady for me. It was so embarrassing. Then the custom's officer searched Gary's entire van, even removing all the tires. I prayed, *Lord please don't let me end up in jail just because I'm riding with these guys.* Finally, the customs officer stood up in triumphant. He held up a small matchbox with some marijuana seeds. He confiscated the van. He informed Gary of a future court date and released us with our well-searched belongings.

Now we all had to hitchhike. As we stood on the edge of the road I burst out laughing. Peter, laughing at me laugh, asked, "What's so funny?"

"Look at us," I said, "Here I'm standing on the side of the road with my backpack and small suitcase. Along side me, you two are standing with your backpacks, guitars, and pet dog. It's raining and the sun is setting. All I can do is laugh."

Peter said, "My parents' summer home is located in Sugar Hill, New Hampshire. It's nearby, so we're going to hitch a ride there."

"Wow, if someone gives us a ride it'll be truly amazing," I said.

Within an hour, someone driving a van stopped and gave us a ride to Peter's family summer home. Exhausted from the day's events, we took hot showers, ate, and slept. It turned out these two gruff-looking young men had wealthy parents.

The next day Gary, rented a car and we were on our way again. I decided to go to the commune with them for a week. It was located in Greenport, Long Island.

I liked the people and it was fun working together for a common cause. We took turns cooking, cleaning dishes and other chores. The local grocery stores gave us their misshaped vegetables every few days. The Mary Ogden had a beauty about her. I could see why they wanted to refurbish her and get her sailing.

During that week, there was a day set for a great bra-burning rally. In Rochester I had just signed a petition that women shouldn't have to show whether they were married or not by having to use Mrs. or Miss before their names, while men only used Mr. They wanted the prefix Ms. to be substituted for both Mrs. and Miss. Women's liberation was in its radical stages.

I asked Sue, one of the ladies in our commune, " Why would you want to burn your bra?"

Sue said, "It's about women's liberation. The bra is a symbol of bondage, because it is so binding. It's like a girdle. It keeps you from breathing, it's restraining, and for what? Do you see men all bound up from their clothes?"

I thought about it for a moment. When I was eleven, I was so anxious to wear a bra because it was a symbol of me becoming a woman. I never really complained, but I hated wearing a bra. It made it difficult for me to breath. I couldn't wait to take it off at night and take in a big breath of air. On that special day, I joined the other women and threw my bra into those burning flames. I felt liberated.

My allotted week over, I hitchhiked back to Rochester, New York. I found two jobs, intending to save money and go back to the commune. I got a job at a submarine sandwich shop, and another working at the parking lot booth in the airport. I loved the parking lot ticket job because I got to read books in between flights. I kept thinking about the commune people and sailing down the Amazon River.

Then my birth dad called me.

Dad said, "Irene, I have a surprise for you. Come to my apartment."

I arrived at his apartment and he showed me a car.

"It's a 1957 Chevy Station Wagon," he said proudly. "It's passed inspection. You just need to get a license and insurance. What do you think?"

"It looks big, Dad. Why don't you keep the car?"

Dad replied, "Irene, it's time for you to drive."

"Thanks Dad, I guess. I'll have to figure out the insurance thing first."

I called different friends to figure out what I needed to drive a car. I studied for my driving test. Then the day came to take the test.

I was so scared taking my road test. I said to the driving tester, "Why won't the car move?"

He smirked and said, "Young lady, take your foot off the brake and put your foot on the gas pedal."

I looked at him and said, "Did I already flunk the test?"

He shook his head. "Young lady I can't flunk you yet, because you haven't started yet! Now drive carefully. You still can pass the test."

I was quite a sight. I sat on two pillows to see out the window and had two more pillows behind me so I could reach the gas pedal. To my great relief, I was able to parallel park that huge monster. I passed the road test!

Shortly thereafter, my high school friend, Jim Smith offered to help me drive back to the Greenport commune. On the way, we picked up student hitchhikers as we saw them. At

one point the car was filled with seven people. As each new person entered into the car, that person thought that the rest of us had already known each other. We would introduce ourselves, start laughing, and reveal that we had just met. We shared our travel stories. It was a unique time.

A few weeks after I arrived in Greenport, The Mary Ogden Ship was towed to Essex, Connecticut. Essex, a beautiful little sailing town, became our new communal home. We learned some jobs in old time shipbuilding. I was taught how to tap the hemp in between the ship's boards and seal them. Other times, I was on kitchen duty. Jobs were rotated so we could each learn new tasks. In addition, a local minister offered us part time jobs so we could earn spending money. Essex was a beautiful community. I felt a sweet happiness there.

<div align="center">Ψ</div>

Will it be Adventure or College?

About three weeks before college was going to begin, I did some soul searching. I asked myself, "Do I go to the Amazon or do I go back to college?" As much as I craved adventure, I recalled my third grade teacher from the ghetto, Mrs. Curry saying how important it was to get an education. I never wanted to be that poor again that I had to live in a ghetto. A shiver of fear ran down my spine. My practical side told me to get my education.

I found a public phone booth and called my mom. "Hi mom, I'm going back to college in Missouri."

"How are you going to pay for school and an apartment?"

"If I can't come up with money, I'll live in my station wagon car. I'll find a safe place to park it."

"But you can freeze to death!" She said.

"I have long johns and a warm sleeping bag. I'll get a job and figure it out. Don't worry, mom. I'll be all right. I'll come home and see you before I drive to Missouri."

For almost an hour, on my drive home, I got caught in a busy traffic circle in downtown Albany. I felt dizzy going in circles. Finally, I exited. A little while later I saw two students hitchhiking. I pulled over and asked if they had a driving license.

They showed me their licenses. "If one of you'll drive for a while, I'll give you a ride."

They agreed. We quickly became friends. They drove my car all the way to Rochester. I invited them to eat dinner with my family. My mom let them stay overnight on our sun porch. After breakfast, I drove them back to the Highway.

Meanwhile, mom had cashed in a life insurance policy she had for me since I was a baby. It was about two hundred dollars. She gave me the money towards my college tuition. My birth father had saved up another two hundred and fifty dollars for me.

Heading back to Missouri for college felt right. Once there, I shared a $75.00 per month apartment with my new friend, Linda. College tuition was about two hundred dollars per semester. I was able to get a student job. For five dollars, I bought a full chicken, a pack of cheese, a box of oatmeal, and a loaf of bread. That was one week's groceries. As I grocery shopped, I promised myself that when I had a little extra money, I'd buy myself a jar of Schmucker's Raspberry Jam. As I stood in line waiting to pay for my few items, I noticed other people with carts full of food. I stood there wishing that someday I would be able to afford to eat well.

Chapter Three

Desire for Art, Life, and Travel Unleashed

Ψ

Identity Crisis: Fueling My Desire for Art

*A*fter I finished that fall semester in Missouri, I applied and transferred to Monroe County Community College in Rochester, New York. I stayed briefly with my parents until I was able to afford both school and an apartment. At Monroe Community College, I had an innovative history teacher, a woman from India. She emphasized how the intellects in society, including artists, poets, philosophers, and writers often led the way for change in both war and peace. For my history term paper, I wrote about historically influential artists. My research for the paper made me realize that artists were every bit as intelligent as scientists.

I fell in love with a fellow student, even though I felt we didn't have a lot in common. Phil seemed totally fascinated with comic books. Sometimes I went to comic book stores with him, even though they didn't fascinate me. I met him at a dance, but we didn't go dancing anymore. And dancing had been important to me. We mainly hung out where he rented a room with other students in a large Victorian home located near downtown. I liked that he sang and played the guitar. However, when he played his organ, with its different sized pipes and all, the music reminded me of church and funerals. I didn't want him to know that the organ music depressed me because I didn't want to stifle his love for it.

Not too long after one of his nights of playing organ music, I sat cuddled in his lap, on a rocking chair. We were sitting out on the porch of his old Victorian Home.

While holding me in his arms, Phil asked, "Irene, how do you see our future together?"

"I guess we'll get married, have some jobs and have children at some point," I said. Suddenly I burst into tears. Sobbing and sobbing, I couldn't stop crying. I felt deeply depressed. Life looked pretty boring summing it up in a few sentences. My answer and reaction must of scared him because he broke up with me the next day.

Partly because I gave up things I liked to do in order to be with him, and partly from the recent heartbreaks, I felt lost, like I lost my identity. I felt a deep sadness and I wanted to overcome this painful feeling. I began to think that my happiness depended on me. After crying on and off for three days, I spent a whole night awake analyzing my life from my earliest memories to that present moment, at age 19. I questioned myself. *Who am I? What is it in life that makes me happy?* That night so many memories were of me wanting to paint and other people keeping me from it. I saw the patterns. Even though, I liked math and science, my heart cried out for artistic expression. In realizing this, I was on my way to being happy.

The next morning I went to an art supply store and bought canvas board and paints. I started painting. I went to the library and studiously devoured hundreds of books on artists and their work. My first three favorite artists were Henry Roseau for his paintings of innocent dream-like qualities, William Blake for his poetry and spiritual symbolic paintings, and Vincent Van Gogh for his paintings of vivid colors and emotional textural strokes. One of my first paintings, *Hands of Creation* (see Fig. 8A) has a male and female hand coming together to form light and fire.

In December of 1971, I received my two year Associate Degree in Science from Monroe Community College. Somehow I forgot to apply to another college and was going to have to wait until next September. I needed a job in order to save money for tuition. In the dead of winter, going on job interviews was no easy task. I was freezing from the cold

winds and the deep snow overflowed into my boots, freezing my feet, all while waiting for busses. My legs turned blue from the freezing cold weather, because I was told that if I wore a skirt, it was more lady-like and I had a better chance of getting a job. At times like these being a woman sucked.

Fig. 8A Irene Vincent, *Hands of Creation*, 1971, Oil on Canvas Board, 16"H x 20W

Then my friend, Linda, with whom I had previously shared an apartment in St. Joseph, called me. She was now studying for her master's degree in English Literature at the University of Miami.

Linda said, "Irene, the weather is warm here. You can stay in my dorm room and even sit in on some of my classes. The teachers don't call role. I know how much you love learning new subjects. You can get a job here. There's a new university called FIU and it's reasonably priced."

"Wow, warm weather and sunshine," I said with enthusiasm. "How can I resist?"

<p align="center">Ψ</p>

The Art Muse Awakens: Miami

I booked a flight to Miami and was on to a new adventure. I stayed in Linda's dorm room. She warned me that the dorm mother often came in the middle of the night, in order to catch friends and parents of student's staying overnight, and no one was allowed to stay overnight on campus except for the students. If caught, I could be fined $25.00. I only had $50.00 in my bank account for an emergency and didn't want to loose it. To be prepared, I asked new friends if I could stay with them incase I had to sneak out of the dorm. My other possibility was to sleep on the wide branch of a tree in Coral Gables, a wealthy neighborhood where I would be safe. I was just scared of the huge flying Palmetto bugs, which were like huge cockroaches with wings.

I loved the warm mild winter of Miami. The land was flat which gave the sky a beautiful vastness akin to the ocean's vastness. The azure sky would fill with cumulous clouds and turned into beautiful pink, rose and orange colors at sunset. Colorful tropical plants sporting unique flowers and tall royal palms graced the Campus landscape. I checked out the possibility of getting some kind of financial aid or scholarship to go there, but it didn't look promising.

I spent time reading books on artists and painting. I hung out around the outdoor snack bar, meeting and talking with different students. I dated a few different young men. Then, I

met Ron and it felt so right as we talked and laughed. I couldn't wait to tell Linda about him. I felt peaceful on my walk back to the dormitory.

"Linda, I met a student today. I really like him. I think that he'll be a lifetime friend. It just felt so right. I gave him my phone number and he gave me his."

"Sometimes we do sense when the person is right for us. I hope he calls you soon."

Later that day, Ron invited me out for pizza, then swimming at his apartment pool. We had fun together and immediately felt like best of friends. I stayed over at his place a few times. Then he told me that he was going home to Baltimore, Maryland for a week to visit his parents and friends. He told me that if anything happened, I could call his roommate.

A few days later, as luck would have it, the dorm mother came at two in the morning. All seven of the dorm girls were at their boyfriend's apartments. I didn't have time to hide under the bed. Besides, it was a small single bed in a sparsely furnished room and there was nowhere that I could really hide. The housemother drilled me and told me that if I didn't leave immediately, she would double Linda's $25.00 fine. I got dressed and left. I remembered a student, Tom, who told me that if I really needed a place to "crash," I was welcome. His house was about a mile away. I told him that if the time came, I would do his dishes or some housework in exchange.

When I got to Tom's house, one of his two roommates said, "I'm Jerry. Tom and Bill are at a concert with friends. I'm sure it's okay for you to stay overnight. You can crash on the couch."

Around 3:30 a.m., Tom and Bill arrived with their girlfriends and a few other students. Tom smiled and said, "Hi Irene."

Bill balked at me and said, "What are you doing here?"

I told him what had happened and said, "Tom told me I could stay overnight if I needed to.

Bill said, "We're having a private party."

Tom said, "Don't listen to him, Irene. It's okay for you to stay."

I felt embarrassed and rejected. I didn't think that I could hold back my tears, so I grabbed my things and ran out of the house. I finally pulled myself together and quit crying. I was walking through a slummy neighborhood. As I got close to the University, I crossed the street to be on the other side because I thought that it would be safer. Then the campus police car stopped near me.

The officer yelled at me from his car, "Show me your campus I.D."

"I don't have any," I replied frustrated.

"It's illegal for you to be on this side of the street." All of a sudden he got an emergency call and said, "You wait right there. Don't you dare move! I'll be right back."

As his car sped around the corner, I ran as fast as I could down the street. I found a pay phone and called Ron's roommate, Tim. I was crying and trying to explain what had happened to me.

He said, "Don't worry, Irene. I'll pick you up. Go sit outside your girlfriend's dorm. The housemother doesn't come back twice in one night. I'll be there in twenty minutes."

When we got to the apartment, Tim offered me a cup of tea. I accepted.

Tim said, "Irene, you know we used to have another roommate. You can have that room until summer break."

I said, "I don't know how Ron will feel about me staying in a room here full time. I've only dated him a few times. I may cramp his style. I don't know if he has other girlfriends. We'd better ask for Ron's permission."

Tim replied, "Look Irene, I've already paid for my share of the apartment. I'll be leaving in a week. My dad found out that I was doing drugs. He's making me go back home to Texas. I'm giving you my share of the apartment, no matter what Ron says. Besides, I think he likes you. So don't worry. I'll talk with you tomorrow morning. Here are some towels. Go to sleep."

"I really appreciate your help."

When Ron walked in the door of his apartment and saw me, he was really happy.

He said, "I'm happy that you're sharing the apartment with me, Irene. I don't plan on dating anyone else, so it won't be awkward."

Life took a turn for the better. My gay friend, Erick, was able to help me get a job as a student assistant in an Entomology research lab in the jungle part of Miami. Erick worked there as a student assistant. We shared a love for art. Erick came by the apartment and drove me to work on his motorcycle; otherwise I wouldn't have been able to get to work.

He parked his cycle in the designated dirt lot. While walking through the jungle that surrounded the facility's small buildings, I noticed scorpions, spiders, and other strange bugs. These sent chills up my spine. My job was to sit in a dark room with an infrared light and sort out piles of dead fruit flies that were marked with different colors of fluorescent paint according to the height that they were caught in traps. Orange covered flies were caught at ground level, yellow covered flies were caught at five feet and green covered flies were caught in traps hung at 9 feet. I would sit with my feet crossed legged in the chair and pray that no scorpions or big spiders were lurking around me. After a month or so, I had separated and counted all the dead fruit flies. As if that was not enough stress, the next job entailed that two other students and I clean up a few outdoor type rooms filled with years of dust and spider webs with colorful live occupants. There were large glass beakers everywhere with strange looking spiders in them. Some were dead and some were alive. I shook with trepidation. Only the thought of my paycheck kept me going. This job made me realize that I didn't want to be a biologist. However, it reinforced my desire to be an artist.

Meanwhile, Linda and I saved money for a trip to Europe at the beginning of summer. Unexpectedly, Linda got called into the Peace Corp at the beginning of summer, instead of at the end of the summer.

Linda called me and said, "I'm sorry Irene, but the Peace Corp told me that I either come now or don't come at all. You know I've always wanted to be in the Peace Corp."

"Wow Linda," I replied with heart wrenching sadness. "This is such a bummer. I'll have to go to Europe all by myself . . . alone."

"Can you go with Ron and his friend?"

"Ron said that he and Bernie had planned their trip all through high school. I don't think they want me tagging along. My friend, Don, who I met in Boston, invited me to stay with him and his family, if I ever go to Paris. I'll write him and let him know that I'm coming to Paris this summer. At least I'll have a friend in one country. I'm a bit scared to go to Europe by myself."

"I'll think of you when I'm in Afghanistan."

"Be careful Linda, please take care of yourself. And write me."

"I will."

That night when Ron came home from the University, I said, "Linda can't go to Europe with me, so I'm going alone."

"Ron said, "I don't think you should go alone. I'll ask Bernie if you can come with us. You should know that Bernie and I already know every site that we're going to visit. So this trip is for Bernie. Whatever he wants to do, he gets first choice."

"Well if Bernie says yes, make sure he wants to see art museums, or else I need to travel alone."

"You know I like art, Irene. We'll see art museums. My dad and I painted every Saturday with an artist for over a year. I loved it."

Ron called Bernie. Bernie agreed that I could go. I was relieved and elated. So we immediately arranged to book me a ticket on the same airlines. It was too late for me to get a u-rail pass (a special pass to ride the train all through Europe for a month for a small price). I would have to buy my pass in France. I had no idea how I was going to make that happen.

Ψ

Adventures in Europe

I flew from Miami to meet with Ron and Bernie in Baltimore. We had a week before leaving for Europe. Ron's mom, Dolly gave Ron and me some jobs to do in her large office, so we could earn money while we waited for our departure date.

I really liked Dolly. She was a beautiful, enthusiastic businesswoman, as well as a gracious hostess. One night she cooked and hosted an exquisite dinner party for Ron, me, and six of his friends. She set the table with her finest chinaware. We played tennis with her and Ron's step dad, Maurice. I saw Dolly as my new role model of an ideal woman.

Ron's father, Stan took a few of Ron's friends and us out to dinner. Stan was enthusiastic about business, art and life. He loved to tell jokes. I loved Ron's parents, almost as much as I loved Ron.

Soon it became time to set off upon our big adventure. We flew from Baltimore to New York City, and then flew to Belgium by way of several countries. The Dutch part of my ancestry had come from Belgium, so it seemed peculiar that this is where my European trip began.

We arrived late at night and found a room for three people for $5.00, which included our breakfast of eggs, breads, cheeses and coffee. I was on a budget of $3.75 per day, while Ron and Bernie were on a budget of $10.00 per day. So I had to eat a lot of bread and cheese, while they got better meals. And when they did something that cost money, I waited in a park for them to finish.

We trekked to art museums, cathedrals and sites in Belgium, Germany, Holland, Switzerland and Italy. In Belgium, Magritte's surrealist paintings were in many of the galleries and in the art museums. I loved his paintings' philosophical qualities as well as their surreal qualities.

In Germany, I loved the art of the expressionists. I was amazed by Edvard Munch's ability to convey the raw emotions, feelings and pain of the people he depicted in his paintings. I was enthralled by Oskar Kokoschka's artworks and how he had captured raw passion, yet had a beautiful rendering of anatomy in his figures. I loved the strong determined lines and the compassion of Kathy Kollwitz's drawings. I was inspired by the colorful, more airy spirituality of Wassily Kandinsky's paintings. I was seduced by the illicit sexual overtones and beautifully rendered, yet slightly distorted lines in Egon Shiele's art. For similar reasons, I loved Gustov Klimt. Also, I admired how Klimt used patterns that flowed in and around the figures in his art. In the museum, I stood in awe, as I appreciated and savored the beauty of each artist's works.

In Amsterdam, the colorful textural paintings of Van Gogh emitted love to me. I was amazed how, standing close to look at a Rembrandt portrait painting, it was sensuously abstract, and backing away it became so realistic.

Shortly after we made it to Holland, I told Ron and Bernie that I needed to go to Paris where I could buy a train pass. They wanted to travel on to Sweden. I was starting to run out of money and I wanted to see the Louvre and other museums in Paris. They wanted to go to Paris at the end of the trip. So we parted ways. I promised them that I would meet them in Munich, Germany in sixteen days. I was off to Paris by way of Germany.

I took a train to a town where I could tour a German Castle. On the train I met some young German people who barely spoke English, and I barely spoke German, yet they invited me to stay at their farm. I got off the train with them and stayed at their farm for about four days. Lots of young people passed through and I was introduced as their American Guest. I practiced speaking German with them. It got boring for me, so I asked a visitor with a car to drop me off at the nearby castle. I had always wanted to see one, but once inside it had such a cold feeling, and I don't mean just the temperature. I moved quickly through the tour and headed back out to the autobahn to hitch a ride to Koln.

The cars zoomed fast by me. I didn't think that anyone would stop. My first ride was with a man who kept grabbing my leg and saying lewd things to me in German. In a stern tone, I said "Halten sie, das Auto." To my amazement, he pulled the car over to the side of the rode and motioned for me to get out.

I was scared to stick my thumb out again, but I had no clue where I was. I'm thinking, *Oh God, how do I get myself in these predicaments*? My next ride was a kind German man who spoke English. He gave me a ride all the way to Koln.

Once in Koln, I met a young French man in a café. Jacque was also a budding artist. He couldn't speak English and I couldn't speak French, so we tried to communicate with our broken German. We each had dictionaries, but that didn't work well. We spent the day in art museums.

Towards night, I told him I needed to find a youth hostel. He told me not to waste my money. He had a friend that slept in the park for free and I could sleep near him and be safe. Jacque introduced me to Heinz. Heinz appeared to be my age. Heinz took me to the park and motioned for me to put my sleeping bag near a tree. He told me I could hitch a ride to France from the highway below, the next morning. But then, he took off, and set his sleeping bag next to a tree about 100 yards away. I thought that was weird. Then it started raining. I was too scared to sleep, but I finally dozed off.

All of a sudden a car came across the grass towards me. Some teenagers said they were looking for their sister. They told me that I wasn't safe there and then they disappeared. Heinz was still at the other tree. I dozed off again.

Then a police car with sirens and bright lights came racing towards me. "Achtung Bitte!" The policeman continued in German saying that it wasn't safe for me to be there, that I shouldn't sleep there.

"It's late and I don't know where to go," I said in English, hoping he would speak English to me.

"Stay and sleep at your own risk," he said. "We are taking that man near the tree to the police station."

"Then take me to the police station. I don't want to be left alone, out here in this park."

He stared at me for a moment and jumped back into his car. They sped over to where Heinz was and took off with him.

Suddenly there was silence, dark and rain.

Exhausted, I tried to stay awake waiting for the break of dawn. I snoozed off. Then I heard Heinz call my name. It was light again. He said that he was old enough to leave home, but his wealthy parents often called the police to find him. Heinz walked me to where I could hitch hike and waited with me until a truck stopped. He talked with the driver. Heinz told me that the driver would drop me off in a small town near Paris.

When the driver dropped me off, he said that he was sorry that he couldn't take me to the train station. He said someone would help me. I asked a few different people in English if they knew where the train station was, but they just stared at me and shook their heads. I asked people if they spoke English, then they really ignored me. I started crying. My feet were covered in blisters from walking and now I was catching a cold from not sleeping and being in the rain. A man with a fishing pole asked me what was wrong in French. I told him I spoke English. Then he asked me in English. I told him that I needed to get to a French train station, so I could buy a train pass. He told me that it was few blocks away and he would walk with me there.

Once we got to the train station, he said that it didn't open for another hour. He asked two male French students to help me buy a train pass when the station opened. They agreed. After he left, they talked in French to each other and ignored me. Finally, in French, they told me I had to buy a ticket to Paris because I could only buy a train pass in Paris. Someone nearby interpreted for me. I gave them money for my ticket.

We sat together. Then a German girl sat next to me. She spoke English. We shared traveling stories and laughed a lot. I told her I had been a science major, but now I wanted

to be an artist. These French students suddenly spoke perfect English because they wanted to join in our conversation. I was happy that they now liked me, but upset at how they had ignored me earlier.

My musician friend, Don had written back to me and said that I could stay with him at his parents' chateau, which was just outside Paris. I wrote him about the approximate date that I would show up. When the train arrived at the Paris Station, by the grace of God, I found a man who spoke English to help me make a phone call to Don from a special phone booth. Once Don was on the line, the man handed me the phone.

"Hi Don, it's Irene. I'm here."

"Where are you?" I heard both surprise and hesitation in his voice.

"I'm in a phone booth in the train station in Paris. You told me to call you and that I could stay at your parent's home for a few days . . . Don, are you still on the line?"

"I'm surprised. Most of my friends only promise to show up in Paris. I'm kind of embarrassed. I've gotten a girlfriend since we last wrote."

"You can just be my friend. I have a boyfriend. Can't you just go to the museums with me? This city is scary to me."

I overheard his mother saying, "Honey, who are you talking to?"

"Hang on, Irene."

"Mom, I invited a friend to come stay with us. She's in Paris. I know you're busy. What should I say to her?"

"Well dear, if you invited her, she must come stay with us."

He proceeded to give me directions on where to catch a smaller train to get to his village located outside of Paris.

The man, who so kindly connected me on the phone, had waited patiently. "I'm going to pay for your phone call," he said. "Then I'll show you how to exchange some of your money and point you in the right direction for your train. And then, young lady, you're on your own."

"Thank you for your kindness. You have renewed my faith. I went through a lot to get here."

Don and his mother met me at their village train station. Don helped me put my knapsack and sleeping bag in the car.

As I hopped into the car, his mom, Diana greeted me with a sweet smile and said, "Hi Irene, I'm glad that one of Don's friends is finally coming to visit him. You look a bit worn out. Are you okay?"

"I've a few blisters on my feet from walking so much and I'm quite tired of traveling. Thank you so much for letting me stay in your home."

"You're welcome. You can take a hot shower and rest before dinner. How does that sound?"

"Absolutely awesome."

Don sat there smiling. Finally he said, "It'll be fun to show you around Paris."

As the car rolled into their driveway, I was amazed at the beauty and size of their chateau. His family welcomed me with open arms. Each morning in their colorful garden, Don and I were served a wondrous breakfast of eggs, cheeses, breads, and fresh fruit. I basked in the sunshine and the garden's beauty, feeling like I had just traveled from Hell to Heaven. I was so grateful.

While sitting in the garden, I drew sketches for possible future paintings. I set my next goals to study human anatomy and take figure-drawing classes. I wanted to be able to express philosophical and political ideals that were brewing in my mind. Don's parents drove us to the "Muse`e de l`Orangerie." Monet's large 2m x 6m Water Lilly Paintings encircled the oval walls of the special built Museum. I immersed myself in the energetic beauty of Monet's paint strokes. I thought, *how could paint strokes dance in colorful abstraction and reveal nature sublime?* I felt my heart longing to paint something heavenly. I wanted to give a gift of some kind to the world, too.

I read that in 1922, Claude Monet offered to donate eight 2m x 6m paintings of "Water Lilies" to the French State, provided that they create a suitable exhibition place for his offered art. The state agreed. The architect Camilie Lef´eure created a gallery of oval walls to display Monet's paintings. The new building was called "The Muse`e de l`Orangerie." Monet's "Water Lilies" paintings were installed in 1927, a year after his death. I felt a bit sad that he didn't get to see his art hung so magnificently, but I was sure his spirit was singing nearby.

While we strolled through the Louvre, we viewed huge mural sized paintings in room after room. I saw mural sized paintings of Raphael and Rubens. Then, of course, we stood in line to see Leonardo da Vinci's Mona Lisa. People who lined up around the painting were transfixed in a state of reverence. When I got close to the *Mona Lisa*, I felt a unique gentle vibration. It was like the painting had its own aura.

Don and I also saw the Louvre's collection of art, monuments, and facades from Ancient Cities. The world was such an amazing place. The art and architecture of Paris itself was so inspiring.

Ten days had passed quickly. It was time for me to go to Munich. During the train ride, I played cards and swapped traveling stories with some other tourists, which helped to pass the time. Previously I had made plans to meet up with Ron and Bernie in the Munich train station. When I got off the train, I walked around the station looking for where I was to meet Ron. At one point, I saw Ron waving to me from quite a distance across the large cement platform. He ran over to me.

Holding and kissing me, Ron pleaded, "Don't ever leave me again. I really missed you."

Surprised, I said, "I missed you, too. How did your trip go? What was Sweden like?"

"Bernie got sick with a strange flu and had to stay in the hospital for a week. I visited him everyday," Ron laughed. "Well, that's because his nurses were young beautiful Swedish girls."

Bernie smiled, "Ron accused me of not getting better because the nurses were pretty."

"Bernie recovered and now I have this horrible flu," said Ron. "I have to go to a doctor as soon as possible. But for now, let's go eat and find a room. I'll stay in the hotel room a few days until I recover." Off we went, arm in arm. I freaked out a little bit about Ron kissing me, especially if Bernie had been that sick.

We went to museums, cathedrals, and sites in Munich. We went to the storey book town of Heidelberg. The cobble stone roads in so many of the cities of Europe connected us to the ancient past. I would think how the men who built the roads put down one rock at a time into the ground. These rocks, each so individual with multicolored shapes have a unique beauty that far surpasses the long monotonous blacktops of modern day roads.

Next, we traveled to Lucerne, Switzerland. Ron went to a doctor in Germany and was getting over his flu. Now, I became extremely sick with the flu. For $5.00, I got a shot from a doctor. It was my turn to stay alone in the room. After a few days, we were hiking in the Alps. The fresh mountain air was so nice and healing.

Soon, we were at the railroad, trying to catch a train to Italy. There were so many students with passes that the trains were overfilled. We would rush to get on the train, only to be packed tightly together. Before the train started, a conductor walked by and demanded that a group of us get off the train. After twice being kicked off, we decided we needed a strategy. It seemed that because we were young and American, we were the ones most likely to be thrown off.

"Look you two, this is the last train of the night," Ron said. "Soon as we get on, we'll hide in the toilet until the train starts."

"You're kidding me?" I said. "With my bulky sleeping bag, how'll I fit in that tiny smelly toilet?"

"We'll just have to hold our noses and squeeze together," Bernie said.

Another hour passed. We were exhausted.

Ron said, "Here comes the train. We get on and find the nearest toilet."

We scurried through the crowd to get on board. We pushed our way to the bathroom. As the three of us squeezed into the bathroom, some of the adults looked at us like we were perverts. We locked the door. We could hear the conductor escorting young people off the train. He pounded on the bathroom door, yelling in Italian, demanding we open it.

I yelled, "I'm peeing! I'll be awhile."

He continued pounding the door. The train started up.

After five minutes passed, there was a gentle knock at the door and a woman's voice said, "It's safe to come out."

As we struggled to get out of the small room, the people laughed and clapped. I smiled and rolled my eyes. We now felt accepted.

We went to Venice first. It was such a beautiful romantic place. However, I ran out of my $3.75 per day budget money and was actually very happy to fly home. I was tired eating bread and cheese. I had discovered so many incredible artists and had so many adventures. I bid my adieu to both Ron and Bernie, who traveled onto Florence and Rome.

Once I was back in the United States, I now had profound moments while watching the TV news. I had empathy for the people in those other countries. They were real. I felt a heart connection to the rest of the world.

So, in being home my inner mind debate came on strong again. Do I go back to the university to study science or art? I now knew that painting took technical skill and that one could put philosophical ideas and concepts into a work of art. Paintings could tell a story and record a moment in history. A portrait could reflect a person's character and soul. Traveling to Europe sealed the spirit of art and adventure into my soul. I figured that if I become an artist, I might not make a steady income, but I might be able to paint and travel around the world. Thoughts of freedom lingered in my mind.

Ψ

Miami and Travels to Greece

When Ron arrived back at his family's home in Baltimore, he telephoned me.

"Irene, I missed you. Will you come back to Miami and live with me? You can get a job and enroll back in college. We'll share a two-bedroom apartment with my classmate, Scott. He says it's okay. I'll pay for our rent and food. You take care of your other needs."

"I missed you, too," I said. "Of course, I'll come stay with you. I'm glad you're back safe. A friend of mine is driving to Florida in a few weeks. I'll see if he can drop me off at your home in Baltimore. Then we can drive there together. Will that work for you?"

"That's great. Call me when you know."

It all worked out. Soon I was in Miami, working 38 hours a week as a cashier in a grocery store that was within walking distance to our apartment. The store wouldn't give me a forty-hour workweek. That way I had to pay union dues without being entitled to any benefits.

I saved as much money as I could from my meager wages. One day a week, I took an anatomy drawing class and a figure drawing class at the Miami Art Center. I painted during my spare time. Most of my paintings depicted philosophical ideals. I discovered the Romantic Poets. Inspired by William Blake's poetry, I painted *The Philosopher Chasing Truth* (see fig. 9). It depicted a Philosopher with a butterfly net, chasing a butterfly over a surreal landscape designed of triangles. During his chase to 'capture truth and beauty,' which the butterfly symbolized, he left a path of destruction, symbolized by fire. In capturing the butterfly, he would kill it. I felt once a philosophy gets frozen in ideology, destruction ensued.

Fig. 8 Irene with self-taught paintings in Miami, 1973

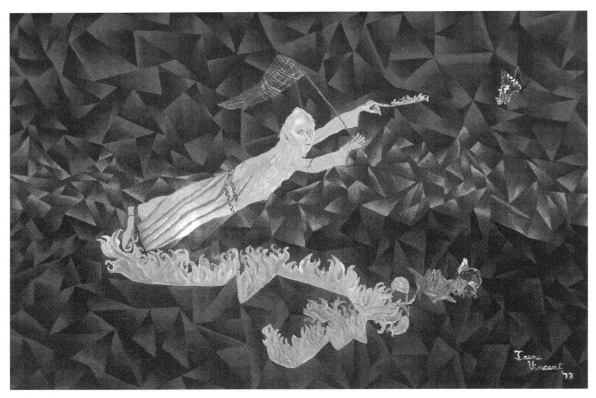

Fig. 9 Irene Vincent, *The Philosopher Chasing Truth*, 1973,

Oil on Canvas Board, 24"H x 36"W

Ron was in his third year in college, studying business management. He was working part time, studying full time. The year went by fast.

Summer was upon us. In order to escape the sweltering humid weather in Miami, Ron and I decided to go to Greece for a month. We were each on a five-dollar a day budget. In Athens, we visited the Ancient Greek Temples of the Acropolis, the National Archeological Museum of Athens, and the colorful local markets. Then we visited the islands of Hydra, Spetses, Mykonos and Pelos.

Hydra was a short ferry ride from Athens. When our ferry landed, women greeted us, asking if we needed a room. Up stone laden streets, we followed a woman named Anna,

passing white washed facades of homes that all appeared to be the same. There was beauty in their simplicity. Their whiteness glowed. I stored these unique impressions in my artistic mind.

Anna showed us a small clean sparse room for $3.50 per night. It came with a cold shower. For $5.00 per night, we were offered a hot shower. We accepted the less expensive room.

Autos were not allowed on the island, which made for plenty of clean air and a relaxing atmosphere. Donkeys carried people, luggage and other items. Cafes and shops lined the harbor. In Hydra, Ron would dive off the rocks into the deep waters and gently place spiny sea urchins into a net bag for a local shopkeeper. The local people considered sea urchin eggs a delicacy. As the news got around, the local shopkeepers befriended Ron and me. We stayed there for a week.

Next we traveled to the Island of Spetses. We rented a room where Roosters woke us up a bit too bright and early. On our second day there, we took a boat ride to a cavernous cove. We snorkeled and swam in beautiful bright green water. The beaches were mainly covered in pebbles and little rocks, so they weren't comfortable to lie down on. On the third day we took a boat to Mykonos.

In Mykonos, as we got off the ferry, some young boys gave us a fair price for a room. We followed them up narrow stone laid streets, twisting and turning. There were hardly any street signs. The shops and homes were all white washed. Finally, we came to the house with our room. We agreed upon a price of $5.00 a night with two hot showers per day. Before it got dark, we asked the landlady to draw us a map of some kind because we feared that if we went to a restaurant we might not find our way back to our room. She gave us a small map, but told us to write shop names or draw identifying images on it as we made our way to a restaurant for dinner. The streets of Mykonos were labyrinthine. We got lost a few times trying to make our way back to the room.

That night as Ron and I started to go to sleep, we heard sounds of a couple arguing, screaming and spitting at each other. We looked at each other with fearful eyes.

I whispered, "Ron, what should we do? He might kill her."

"Shit, he could kill us," Ron whispered.

"How do we get help? We don't even know where the owner is."

"Let's get dressed." As we pulled on our clothes, we heard love making sounds.

I looked at Ron. "I guess that they made up."

"Well, let's go to sleep then."

Just as we started to sleep, they were fighting again. Ron and I held each other tight, trying to comfort each other. The next morning we noticed all our rooms were in one big room. The walls didn't reach the ceiling. We talked with the landlady and she said that the couple was leaving that morning, so we needn't worry. At breakfast, we met Pascal and Monique who were gynecologists from France. They were staying in the third room. They laughed when Ron and I stated our concerns about the other couple.

Monique said, "Oh, they're sadomasochistic. They beat each other, in order to get turned on for sex."

"Why would someone beat a person to make love?" Shocked, I said, "Well, I reason it isn't making love. Anyway the whole thought of it makes me sad."

Pascal said, "Mykonos is known as a jet set party island. So it attracts all kinds of people."

Changing the subject, Ron said, "I read there are very beautiful beaches in Mykonos."

Pascal said, "Today Monique and I are going to the local beach. It's within walking distance. There are two other beaches, Paradise and Hell. You have to take a boat to get to them. Paradise beach has incredible snorkeling. It has an excellent café, which is a good thing, since you have to stay there until the boat comes back for you. It's a nude beach with mostly gay men. Hell is supposed to be the best beach, but it is a longer boat ride."

"Ron and I will join you at the local beach today. Tomorrow, we'll go to Paradise beach. I want to skip Hell. After last night, who knows what kind of people will be there."

Agreeing, Ron said, "I want to do some snorkeling in Paradise. I don't mind skipping Hell, though."

On our walk past shops, I noticed sexually lewd sculptures in some of their windows. *Oh, this is a strange place,* I thought. However, my thoughts quickly turned by seeing the beautiful enameled gold jewelry sparkling from other shops' windows. I bought myself a gold fish pendant covered in blue and green enamel, a special gift to myself.

We enjoyed our day at the beach with our new friends. They shared stories with us about their life in France. We shared our stories. After a fun day, we were able to sleep.

The next day we went to Paradise beach. I sat there on our beach towel with my sketchpad, drawing the beautiful men and reading a book. When I got too hot from the sun, I swam. Ron loved swimming nude, but didn't like anyone looking at him. So he only took off his swimsuit, as he was about to hightail it to the water. I laughed at him, trying to run that fast over the soft sand.

The next day, we took a tourist trip to Delos, the Sacred Island of Apollo. It had been inhabited since 3000 b.c. The temples and shrines were built sometime in the 8th Century. It now was an uninhabited island. It was interesting to see the ruins, but the heat and dry air parched my lips. The tour guide warned us not to go near the large lizards, so I stayed near Ron, hoping not to see one. A few of the lizards scurried by us.

When we arrived back at our rooming house in Mykonos, Pascal was sitting in a chair outside the whitewashed home.

Pascal said, "Have you heard Greece is at war with Turkey? I hope that we can get food in a restaurant tonight. When the news broke out, the local people bought all the food out of the stores. You should have seen the panic."

"Ron and I take the ship back to Athens, tomorrow," I replied, my voice quivering.

"The government has ordered that all boats and ships are to be used for the army only," Monique said. "It looks like we'll be here until the government lets us leave."

"Let's go to a restaurant and see if they're going to serve us," Ron said.

Once there, the restaurant owner told us that the government would ensure that tourists had food.

He said, "I might be short of help . . . most able bodied young men will have to serve as soldiers."

Dressed haphazardly in their uniforms, the young Greek boys walked around with their shoelaces untied and their shirts miss buttoned. They looked like farm boys who had no clue about what they were up against. I felt sad for them and humankind. I thought, *after thousands of years, mankind still had not learned to compromise and communicate. They continued to choose to blow each other up. How stupid is that?*

After a few days, the government let a Ferry take the tourists back to Athens. Ron and I were on standby, since we had missed our flight. We shopped and enjoyed Athens. We finally made it back to Miami.

Ψ

Our Flower Business

Gladly, I'd given up my grocery store job in order to go to Greece. However, now that I was back in Miami, I needed a job. The only job I found was at a large hotel, as a maid.

The hotel manager said, "You're on trial young lady. You have to clean 16 rooms in an 8-hour shift. It's a very physical job. You're quite small in size and will be the only white girl. Do you think you'll be able to fit in with the black girls? And do you really want this job?"

"Yes sir, I replied. I like black girls. And I promise I'll do a good job for you."

"Okay, I'll see you tomorrow morning at 8 a.m. sharp."

"Thank you."

It took me two long bus rides to return to my apartment. Ron was upset with me arriving home so late.

He said, "I can't believe that you took this job. It's a bit embarrassing. Plus when am I going to be with you if it takes you 2 ½ hours to get to work, then you work 8 hours, and it takes you 2 ½ hours to get back home?"

"Look Ron, I need to save money in order to get back into college. I'll just work there until I can find a better job."

"All right, I know that going back to college is important to you. We'll make the most of it."

The new job was exhausting. I was able to get all my assigned rooms cleaned, but each night as soon as I arrived home, I fell on the bed and went to sleep without dinner.

The hotel was across the street from the University of Miami, so Ron got up a little early so that he could drive me to work. One evening, I missed the bus and decided instead of sitting at the bus stop for another hour, I hitchhiked home. A man in a Van stopped. His name was Lonnie. Lonnie was just a few years older than I. We shared stories during the ride.

Lonnie said, "Irene, I have girls sell flowers on the street corners. They make a lot of money in a few hours. You should work for me. I'll pick you up at 1 p.m., drop you and the flowers off at a dirt pull over spot, you sell the flowers, I pick you up at 6 or 7 p.m., and then you get paid a commission."

"I really need the money, so I could sell flowers on my days off work. Once I know that I'm going to be earning money, I'll quit the other job."

"Here's my phone number," he said. "Call me and I'll get you working."

I worked for Lonnie a few times. I loved selling flowers to people.

Soon, however, Lonnie started saying, "Irene, I don't feel like working today. I'm busy doing other things."

Finally I said, "Look Lonnie, I haven't seen any girls out selling flowers at any of your spots. I'm going to start selling flowers myself."

"Well, don't set up at my spots. I built those locations." Lonnie listed off about five places where I shouldn't sell flowers.

"I want to sell near my apartment. So, Lonnie just call me on the day that you're working and I'll find another spot. Anyway, I'm building customers for you."

"Okay, when I decide to work again, I'll call you," Lonnie said.

Meanwhile, Ron and I started a street vending flower business. In order to purchase our flowers wholesale, we had to buy a box of five hundred carnations. I wasn't able to sell the whole box by myself, so Ron started selling flowers at another location. Over the next six months, we built the business from just me selling flowers to having as many as twenty girls on staff. Our advantage in selling our flowers was that we were able to get powerful powered dyes from our wholesaler. The dyes when mixed with water would turn our carnations into all kinds of vibrant colors.

Soon, Ron and I needed more space for all the buckets of flowers. Ron's mom loaned us a deposit for a small three-bedroom condo in a new complex located right near the Everglades. Ron gave me one room to use as my painting studio. He put his desk in our bedroom. The third room, as well as our living room, was filled with carnations, daisies and sometimes roses. Often, the fragrances overwhelmed us.

While waiting for customers, I arranged beautiful bouquets. During our first holiday experience, I sold out of my flowers the first hour.

Ron looked amazed as he pulled up in the van. "I gave you more flowers than anyone else," he said. "How did you sell them so fast?"

"Instead of just selling one for 35 cents or two for 50 cents, I made bouquets and sold them by the dozen. One man told me that he drove sixteen miles hoping that I would be here selling flowers, so he could buy my colorful bouquet."

After that experience, we photographed my arrangements, then had the girls put them together. It wasn't an easy business. We had permits to sell on the street, but on various occasions, local florists called the police and told them to shut us down. The local government changed the permit selling rules, forcing us to design moving carts for our flowers. We kept up with the changing rules, going to court, keeping our business alive. Then competition from New York City moved to town and started setting up flower girls at our spots. The new people would set up at our spots earlier and earlier. Finally I set up along side them and raced them to the customer's cars. Then we set up at their spots to annoy them back. That's when they were willing to agree on which spots were ours.

Also, one day when I arrived home from college Ron looked a bit queasy to me.

"I don't want to scare you Irene, but a big muscular man came to our house today and told me not to set up any girls selling flowers near the grocery store. He said that he wanted the location for his girls to sell flowers. He said that I would be sorry if I didn't give him the spot."

I felt sick to my stomach. "Where did you set up the girls?"

"I put two girls there, anyway."

"Holy shit, Ron, we could be killed during the night."

"He said that he was with the mafia," Ron said. "But, I didn't believe him, at first."

"Maybe we should hire a detective and find out who the man is. And if we aren't harassed tonight, maybe we shouldn't put girls at that spot for a few days and see if they really use it."

We hired a detective and a few days later he told us that the man was part of the mafia and that we shouldn't mess around with him. They only used our spot for a few days and

then disappeared. They never threatened us again. However, I got stomach ulcers from all the threats and uncertainties.

Fig. 10 Irene and Ron

Fig. 11 Irene, Age 25 in Hawaii

Fig. 12 Irene, age 20, in Miami

Fig. 13 Irene, Sandy and Dolly (Ron's sister and mother)

Fig. 14 Maurice, Irene, & Dolly

Ψ

Second Trip to Greece

After our first trying year in the flower business, Ron and I decided to go back to Greece. It seemed safe again. This time we only spent one night in Athens. We immediately took a hydrofoil over to Hydra. The local people were happy to see us. We mostly relaxed, read our books, and swam in the sea. After three days, we took a ferry to the Island of Santarini.

In Santarini, a donkey carried our luggage and us up a steep hill to the hotel. The air was extremely hot and dusty. We ventured down to the black sand beach. The black sand burned my bare feet, so I had to keep my shoes on. But for the bright side of this Island, almost all the restaurants had beautiful views of the ocean and sunsets. It was relaxing.

When we tried to leave Santarini to go to Crete, the travel agent said, "You have to take an overnight potato ship. You can sleep on top of the ship in the open air. Otherwise, you have to spend three more days in Santarini for a ship to come."

"Really, that sounds a bit scary," I said. "Is there any food on board? Are there toilets?"

"Yes. Many tourists travel this way. It isn't so bad. If you want to go, buy your tickets now and be here tomorrow at noon."

Ron and I looked at each other realizing we didn't have many options.

I didn't sleep well, thinking about the next day's ordeal. The next day we ate an early lunch. Then we walked over to the travel agent's booth.

The booking agent said, "The ship is running late . . . go sit in a restaurant nearby until I tell you to head down the stairs."

An hour passed. We were sharing stories with another couple, who was also waiting, when we heard a ship blowing its horn."

I said, "Hey guys, do you think that's the potato boat?"

Ron said, "We better go ask the lady."

We walked over to her booth. Startled, she looked up. "Oh, I forgot about you. The ship is about to leave. You'll have to run down the stairs as fast as you can, if you want to catch it."

I moved as fast as I could down the uneven stone stairs. *I cannot believe that lady,* I thought. *How rude.* My backpack and my bulky sleeping bag tied to it were so heavy. My calves ached. I was crying as I tried to catch my breath. As soon as the four of us climbed up the wooden walkway, the railing gate was closed off and the ship left the harbor.

A few minutes later, people started eating greasy *Savakis* from the ship's restaurant. I grimaced when I saw people eating the spicy meat. As we journeyed out into the sea, large waves rocked the ship. Every other person around me was sticking their head over the side of the ship and barfing up their greasy lunch. Watching them barf was nauseating. I sat down on a wooden bench and stuck a bag over my head, so I couldn't see anyone.

Returning from the latrine, Ron laughing, tapped me on the shoulder. "Are you playing the role of 'I'm a wild and crazy guy?'"

Slightly lifting the bag, I said, "Just let me know when people quit barfing."

Finally, nudging me, Ron said, "It looks like the coast is clear."

As I took the bag off my head, a Greek lady walking by me said, "That was an interesting way to cope."

I shrugged my shoulders and smiled.

We passed the day reading books and talking with other student travelers. As dusk came, many of the people were claiming spots by laying out their sleeping bags. We set up camp near our newfound friends. As it got dark, it became cold and windy. The stars sparkled brighter and appeared bigger to me than ever before. People fell asleep. I lay there worrying.

I whispered, "Ron, I didn't notice many life boats. I think they barely have enough for their crew."

"I was just thinking the same thing," Ron whispered. "Let's blow up our rubber raft. We can put our sleeping bags inside of it. So if the ship sinks during the night, we'll already be in our raft."

"Great idea."

Quietly, we blew up our raft. Feeling secure, we fell asleep. The morning sun warmed our faces. We sat up in our sleeping bags.

Our new friend, Bill yelled out, "Are you guys prepared or what?" All the people around us started laughing.

Finally, the ship pulled into the Harbor of Iraklion, Crete. In Iraklion, we stayed in a small hotel with a veranda that was covered in grape leaves. Ron, Bill, and Jan left to tour the city. I stayed behind reading a book on the veranda. The landlady asked me in broken English why I stayed behind.

Pointing to my calf muscles, I said while grimacing my face, "I can't walk . . . too many stairs in Santarini. I have stiff calve muscles."

She shook her head up and down; she left the room. A moment later, she came back with a big smile on her face, holding out a tube of cream, saying, "Ben Gay. This will help."

I lit up, "Thank you so much."

Ron, Bill, and Jan came back and said that we would leave in the morning. They had bought bus tickets and booked two small rooms in Matala.

"Matala is a coved beach with hippy caves, Ron said. "We'll be back in nature, out of the city. It might not feel so hot there."

During the bus trip around Crete, while looking out the window, I saw four old Greek women playing in the waves and on the sand. They were lifting their skirts to avoid getting them wet and they were laughing. Wow, I thought . . . *when I get old, I want to be playing*

on the sands with my friends. They are gleeful. What a contrast to how I saw old people sitting on benches, looking dejected and depressed in the heat of downtown Miami. I must find a way to live in nature when I'm old, especially near the ocean.

The bus traveled over beautiful cliffs, the turquoise ocean far below. The narrow winding roads were scary at times, especially when other big busses rounded the curves. Finally, we made it to Matala.

Ron and I dropped off our luggage in our room. Then we went for our lunch. I loved eating Greek Salad and Moussaka. I found Greek food very appetizing. Usually the restaurants would have plates displaying the real food from their menu. We would point to a plate and they would cook our food. Many times little boys took our orders, never writing anything down. One day I finished every morsel on my plate. When the little boy came to tell us the cost of our food, he stared at my plate, looking angry. Scratching his head, he left with the plate.

Looking perplexed, I said, "What's that all about?"

The little boy came back and asked me to point out the dish of food I had chosen to eat. Then he happily wrote out our bill.

"Ron, after this long trip, I finally get it. These children waiters look at our plates to remember what we ate, so they know what to charge us. We need to leave a few morsels."

"Well, that makes sense now. I couldn't understand why the kids were always staring at our plates," Ron said. We slapped our legs and laughed.

"Let's go to the beach," I suggested.

"I feel too tired to swim, Ron said. "I'll inflate the raft and we can float around for a while. How does that sound?"

"Sounds relaxing to me."

We put our raft in the sea.

Ron said, "I'll row us out a little way and the waves can return us to the shore."

"This is great. While you do that, I am going to snooze."

Soon, I felt Ron cuddle near me. I don't know how much time had passed, but I woke up feeling the heat of the sun upon my face. I looked for the shore. Ron was snoozing.

Shaking Ron, I exclaimed, "Ron, wake up, I can barely see the shoreline."

Startled, he said, "Here, take an oar and row as fast as you can."

"Ron, we're not getting anywhere."

"I think that the current might be too strong," he said. "Hand me the rope, I'll jump in and assess things." Diving in the water and splashing around, he said, "The water is deep. It's so dark I can't see anything. It's cold."

<div align="center">Ψ</div>

Oh my God

Thrashing around in the water, Ron yelled, "I'm going to swim us ashore. I don't think that rowing will get us there. I'll tie the rope to my waist. You can try rowing on and off."

" Jump back into the boat if I tell you to. I'll look out for sharks."

"Don't worry, Irene. I'm a strong swimmer."

I prayed as Ron swam, towing the raft to shore. I caught myself holding my breath. I was panicking, my insides were restricting; I knew I had to stay calm in order to help Ron.

"Oh sweet Lord of the Ocean, please help us to safety," I prayed.

It seemed like Ron swam for an hour or more before his feet could touch the sea bottom.

He turned to look at me, breathing hard, he said, "That was a close call. We're safe now."

Crying, I replied, "Thanks for saving us. That took a lot of courage."

Ron replied, "I was scared we might not make it. Let's get to dry ground and deflate this raft."

"I don't think that I'll be able to watch any of those lost at sea movies ever again," I said.

We stayed a few more days at Matala, hiking around the beach coves and swimming, then we headed back to Athens. We decided to travel to a new place for our next vacation, so we wanted to shop in Athens and stay an extra day. The airlines allowed us to change our tickets. We bought some beautiful vases decorated with Greek Goddesses. We bought some colorful hand blown glass perfume bottles for gifts. Being young, everything was so new to us.

When we arrived at the airport, we saw many soldiers carrying machine guns. Glass windows had been replaced with large pieces of plywood. A sign read, "Remodeling." All the attendants were very stern and strict.

Looking at all the missing windows, I said, "Ron, something must have happened."

Ron replied, "Maybe another tourist on the plane will be able to tell us."

Once on the plane, a tourist sitting next to us said, "There was a terrorist attack yesterday at the airport, and some of the people on the same flight the day before were killed."

Shivers went down my spine. "Oh my God, we were going to be on that flight, but we stayed an extra day. Ron, we need to call our parents when we arrive in the New York City Airport. They'll be worried."

These close encounters with death made me contemplate the mysteries of the universe. I valued each moment of life as a special gift.

Ψ

Art Major at Florida International University

Along with growing the flower business, I pursued my education. I took a bus over to Florida International University and then spoke with the head of the Art Department to find out the requisites to become an Art Major. It turned out I needed Art History 101 and 102 from the nearby Junior College. Because I was anxious to speed up the process, I discovered that I was able to take the course by studying on my own and reading required art books plus other texts.

A large part of the art course was about the ancient ruins and temples of Greece and Rome. After my trips to Greece, I held a fascination for these ancient art forms. After a month or so, I paid for and took the art exam with a professor present. I passed the exam with a B plus grade, but since I wasn't a full time student at the college, they decided they didn't want to give me credit.

I talked with Mr. Wyrobia, the head of the art department at FIU. He said, "Irene, I give you grace. Since you passed such a difficult class on your own, I trust that you'll read the books for Art History 102. Also, I can see by the paintings that you've shown me, that you have a dedication to be an artist. You can start immediately as an Art major."

I was so happy. I wanted to dance around his office, but I restrained myself. He looked elated.

Florida International University had recently opened and started out as a complement to Miami Dade Junior College. FIU had begun with junior and senior classes. For years, a lot of Miamians were only able to get a two-year degree unless they were rich and could continue their education at the University of Miami. The average student age at F.I.U. was 26 years old. My student peers ranged from 20 to 80 years old. It was challenging, as well as fascinating to be with students of such diverse ages.

Those were some happy years. I loved the art department. We had a visiting artists' program. Every quarter we would invite a well-known artist to give us a lecture and slide show of their artwork. They would come to the painting studio and critique our paintings. The art professors would give the visiting artist a special dinner and a party. Students on the visiting artists' committee would get to attend the party and meet the visiting artist in person.

Robert Motherwell was the visiting guest artist that I remember the most. He had a philosophical nature. I loved his large black and white abstract paintings. The painting professor, Jim Smith invited Motherwell to join in on the critiquing of our paintings. I brought along two large surreal pieces and two large abstract pieces.

Motherwell asked me, "Both styles have a certain high quality of technique to them, but why are you painting two styles?"

I replied, "My philosophical nature is happier working with imagery. The professors here encourage us to explore abstract art since that's what the art world seems to appreciate right now."

"Well, I must say that you're quite ambitious."

I gave a little smile while trying to keep from crying. They went on to critique the next student's art. I thought, *Ambitious, what does he mean by that? It means to me that I seek power or superiority over others. It's an evil word.* I quickly got up from my chair and walked out of the room, headed to the ladies' toilet. When I got inside and saw that no one was there, I started sobbing.

With in a minute, my artist friend, Angie came into the washroom.

"What are you upset about, Irene? Motherwell and the teacher gave you such a great review."

"Yes, and he called me ambitious. That means I don't care about other people."

"You had so many paintings there. I think that he meant it as a compliment that you put a tremendous amount of work into your art," Angie said.

"Maybe, I overreacted," I said. "Critique days are always difficult. I really liked how he complimented you on your sense of color. That was the first time I heard about you growing up in your dad's paint store and playing with the paint color cards. I love the flow of color in your non-descript imagery."

"Are you ready to go back to the room," Angie asked. "You're still going to the party tonight, aren't you?"

"Oh yeah, I don't want to miss a party," I said. I splashed cold water on my face.

That night at the party, Motherwell told me that he didn't mean to offend. He said, "I was impressed by your work, as well as the quantity."

"Well, I'm sorry that I was so sensitive to the word "ambitious." I love your work and I'm glad you came to visit us." He smiled. I smiled.

We also had a visiting artist teach every quarter, adding variety to the staff. I always tried to fit a visiting professor into my curriculum.

During the spring break each year, one or more of the art professors would put together a group trip to New York City. For seven days, the professors and students met up at scheduled galleries, museums, and restaurants. It was an intensive art gathering as well as a great bonding experience.

At FIU, I studied philosophy, jewelry, photography, art history, figure drawing, and painting. Painting was always my joy.

Ψ

Creating Surreal Art

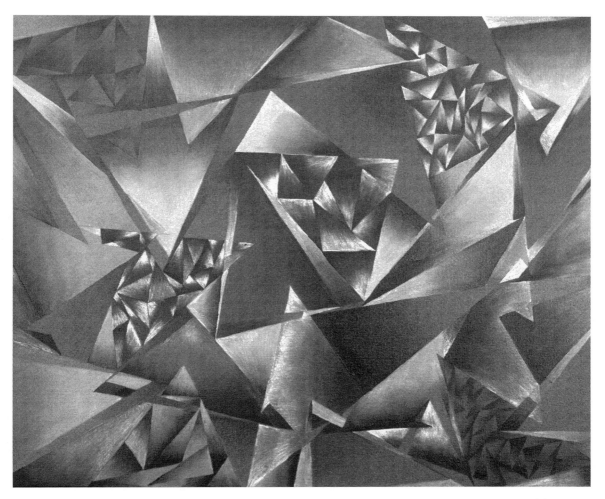

Fig. 15 Irene Vincent, *Interlocking Triangles,* 1974, Oil, 18"H x 24"W, sold

At FIU, there was a short period of time, where the professors let us paint until late into the night. Music blared with intervals of silence as we each fell into the depths of the creative process. We developed close friendships as we watched each other paint. We

101

would talk about art and life until deep into the morning, until the university's night security became concerned and that delightful experience ended. They still let us use the painting studio until 9 p.m., when it was free, but it wasn't quite the same. We had a lot of excess energy.

It was during this time that I created a series of surrealist paintings that fulfilled my need to express my philosophical and technical ideas. These were painted in oil. I became fascinated with triangles. Triangles represented to me the power of the trinity, connecting me to the universe. There was something intriguing about the number three.

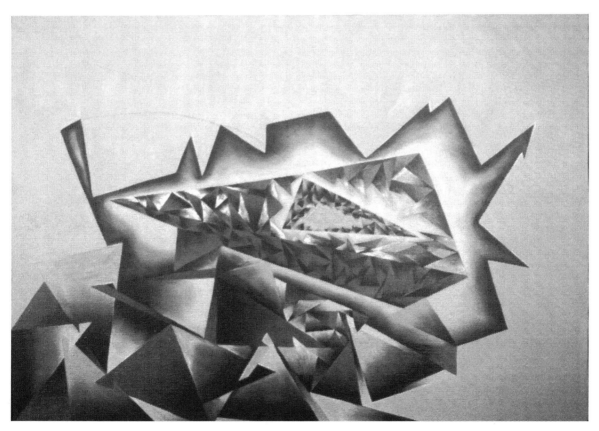

Fig. 16 Irene Vincent, *Triangular Space Station,* 1974, Oil, 24"H x 36"W, sold

While painting, I experimented with shading slowly making transitions more and more refined, causing me to reflect on how I made transitions in my own life. By directing the shapes and points of the triangles, I learned to create a sense of movement. Also, I wanted to capture a sense of space, both literally and figuratively speaking. At first the paintings had a shallow sense of space, keeping the viewer close to the surface. After creating several drawings and paintings, I was able to make the space appear deeper and deeper.

Since I was about 9 years old, I wondered how an artist could possibly paint the essence of air. After all, it's transparent. Hence, I became intrigued with the use of glazes (transparent layers of paint). I read how the old masters used glazes. I wanted to capture an essence of atmosphere in paint.

I was also fascinated with science fiction; Surrealist art came closest to that venue. I had an underlying desire for my images to be strange while invoking a sense of awe and love in the viewer. Philosophically, I wanted my strange worlds to transform the viewers into seeking the unknown with a spirit of love and appreciation, rather than fear and trepidation.

Another painting of mine was actually inspired from the boxes of colored candy at the movie theater. I thought about how the candy could be translated into little colored floating planets in space that could also be harvested as food. I did a few sketches on paper playing with the boxes, distorting their perspectives. The flat triangles of my earlier art, now became transparent three-dimensional triangles, crystalline like structures. From the web of crystal triangles, a type of outer space docking zone was created for my outer space food-gathering factory. The spaceman sits on the front stairs of his business, looking out at the universe.

I chose the transparent purple color to create an unusual atmosphere. I felt happy when I looked at the painting; therefore, I named it *Another Happy Reality* (see fig. 17). When adults and their children viewed this painting at an art show in Miami, they told me that it made them happy. One man told me that as a child he had a recurring dream that he had

traveled to a planet surrounded by a purple atmosphere and transparent triangular constructions. Another friend said that he felt spiritually transported by the painting. I basically think that I was so overjoyed with painting that my happiness spilled through onto the canvas.

Fig. 17 Irene Vincent, *Another Happy Reality,* 1975, Oil on Canvas, 48"H x 60"W

My painting *Breakthrough: No Mind Limits* (see fig.18) depicted the concept that the human mind is limitless in its understanding of life. I sensed that my mind's abilities were limited by self-imagined limits. For example, even though I was now studying art, I still

felt bad about dropping my Calculus course at Missouri Western College. I remembered that one three-hour homework assignment had taken me twenty hours to complete, because I didn't know how to use a slide ruler. The professor took me to a room and showed me a calculator that did the math. The calculator was as big as the room.

Professor Boyde said, " This calculator costs over twenty thousand dollars. You can use it, Irene, but you'll be held responsible for any damages done by misuse."

He might as well have told me it was worth a million dollars. I dropped out of calculus, even though I had always loved math. Afterwards, I had this dragging down feeling that I had reached a limit in my mind's ability to understand higher math. Approximately fours years later, I could buy a hand held calculator for seventy dollars that could do calculus. So, for an elective, I took calculus and received an A. The professor even tried to get me to change my art major to math. Math was still challenging for me, but I was determined to prove to myself, I had not reached my limit.

Fig. 18 Irene Vincent, *Breakthrough: No Mind Limits,* 1975, Oil, 8"H x 10"W

I painted this little painting to remind myself not to put up imaginary walls of self-limitation. I depicted walls with holes in them, showing the vastness of the landscape through the holes. This symbolized that we each have the power to break through our self-imposed limitations … and that the knowledge on the other side of the wall is expansive.

My next paintings *Underwater Garden* (see fig. 19) and *Mixed Drinks in Outer Space* (see fig. 20) were both 14" diameter round canvas studies for my larger painting *Space Garden*. These paintings were both influenced by Ron's and my love for beaches and snorkeling. We would see unusual worlds of coral and colorful fish. The latter painting, *Mixed Drinks in Outer Space* was influenced by my musings of the night sky and of outer space worlds.

Fig. 19 Irene Vincent, *Underwater Garden,* 1976, Oil, 14" Diameter

Fig. 20 Irene Vincent, *Mixed Drinks in Outer Space*, 1976, Oil, 14" Diameter

For my next painting, I desired to combine the beauty of the ocean's coral gardens and an imaginary outer space landscape. I drew some small drawings creating an extended reality of *Another Happy Reality*. I had a liquid gently falling out of the crystalline structures. My space people basked in the shells of their harvested planets. The rose colored atmosphere with its soft blue grays were to give a sense of love and peacefulness. From these desires *Space Garden* was created.

For the first layer of paint on the large canvas for *Space Garden* (see fig. 21), I used a huge house brush with different thicknesses of transparent Payne's Gray mixed with a copal and linseed medium. I swirled the paint in circles onto the canvas creating a vortex. I added a little transparent white near the vortex and swished it on in circular movements working my way outward toward the canvas edges. I let the paint dry for a week.

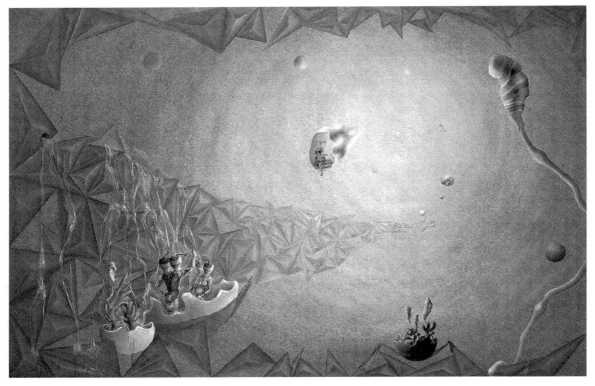

Fig. 21 Irene Vincent, *Space Garden,* 1976, Oil on Canvas, 48"H x 72"W

Then I mixed the colors, Alizarin Crimson and Rose Madder together. I used the large house brush again to paint the circular movements using a more transparent mixture as I got near the vortex.

I was so excited about getting to the next step. For seven days, I would go into my studio to see if the paint was dry. I knew that I had to finish it in time to get credit for the painting class.

When I went to my class, Prof. James Couper asked, "Irene where is your painting for the critique?"

"I put a glaze of Alizarin Crimson mixed with some Rose Madder on the canvas and it isn't drying."

"Alizarin Crimson is a slow drying color. Next time you may need to use a dryer additive to your paint medium. However, you need to be careful of dryers, because if your oil paint dries too fast it can crack. I suggest you find a book on oil painting techniques. There is a lot of chemistry to oil painting."

"Well, I guess I better switch to working on my Geometric Acrylic Paintings for my class credit, because it might take a long time to dry."

After talking with the teacher, I walked over to the bookstore and I bought a book titled *The Artist's Handbook of Materials and Techniques,* by Ralph Mayer. It became an everyday reference book for me. I also went to the library and took out a few books on color theory.

It took three weeks for the Alizarin Crimson layer of paint to dry. Finally, I was able to paint in all the triangles and shade them. Then I painted the coral-like plants and the blue space people.

 When the painting was shown at the annual student art show, it was written up in the newspaper art review for its technical qualities and its playful Boshe-like resemblances.

Recently, a young viewer said, "*Space Garden* is like a parallel universe, representing at the same time, an underwater scene and an outer space scene."

In *Triangular Family* (see fig. 22) I explored making figures out of triangles with veils of transparent cloth draped over them. Originally, the background was of a darker blue, giving the painting an ominous feeling. I then painted a few transparent layers of a lighter color, changing the mood to a lighter feeling. *Triangular Family* looked to me like the marching of some mechanistic alien bird family. It had a beauty, but it spooked me.

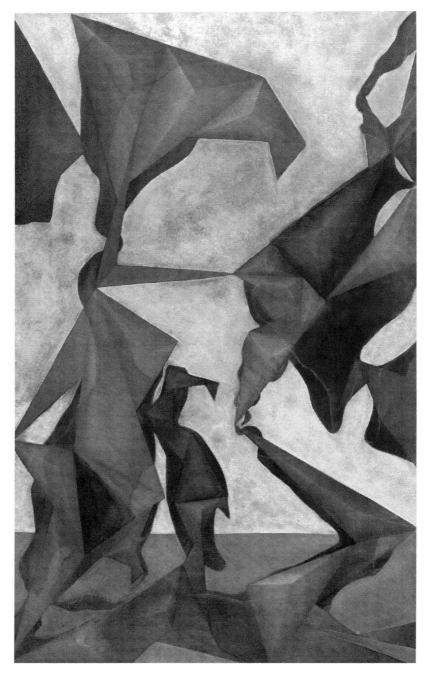

Fig. 22 Irene Vincent, *Triangular Family,* 1975, Oil, 60"H x 36"W,
Background Repainted 2007, Copyright 2007

In my next painting, I left the triangular worlds. Wherever I traveled, I photographed rocks when I saw images of animals, creatures and faces in them. In *Bird People Kissing* (see fig. 23) a bird couple is kissing on a rock shaped like a bird's head. I also wanted to show the ecstasy of a kiss.

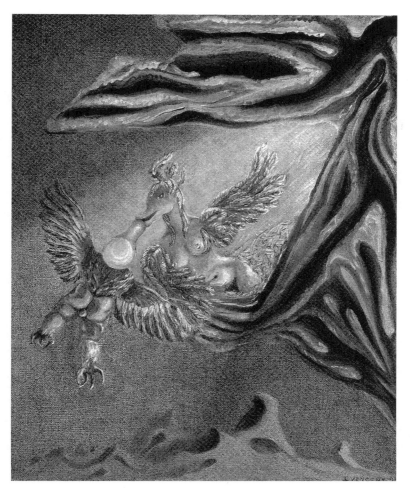

Fig. 23 Irene Vincent, *Bird People Kissing,* 1977, Oil, 16"H x 12"W

Also at this time, I took an exhibition-museum class. We hung art exhibits for the students, teachers, and visiting artists. Hanging paintings was an art form in itself. In

addition, I joined a group of women artists called W.A.I.T. (Women Artists It's Time). We procured a number of venues through which to show our art. We gave a lot of artistic support to one another.

<center>Ψ</center>

Creating Geometric Abstract Art

While painting the surreal series, I also experimented with painting a series of geometric abstracts. Abstract art was highly encouraged by the professors. I explored geometric shapes using both pure and monochromatic colors in acrylics on raw canvas. As with oils, I used opaque colors and transparent colors.

I started by making several small geometric sketches. Penciling in dark and light areas of the sketches created movement. Then I chose the sketches with the best movements and shapes for translation into four-foot by four-foot paintings.

I taped off some of the geometric areas on the canvas. I sealed the edges of the tape with matt medium. I mixed matt medium with the paint to soften the color. I sprayed paint on areas using an old hand held type of bug sprayer, creating a variety of large and tiny paint drops as well as a surprise element: the paint drops sunk into the raw canvas creating a quality of softness.

I explored various ways of depicting tension and attraction. As in the paintings *Tension* (see fig. 24) and *Atmospheric Tension* (see fig. 25), I used what I called the "synapse effect." I thought about how the two fingers reaching to touch each other in Michelangelo's famous painting, those fingers creating a tension for us as a viewer, our minds and hearts wanting them to complete their action. We want them to touch. In an abstracted case of a broken line, there is a sense of our minds jumping the gap, completing the line. I read how our brain had nerve-ending gaps called synapses and our energy

<center>112</center>

thoughts have to jump these gaps. Therefore, the outer gap tension and attraction feeling could be a reflection of our inner synapse workings. I also found that drawing the lines in the square paintings at diagonals created an expansive type tension. I played with these concepts.

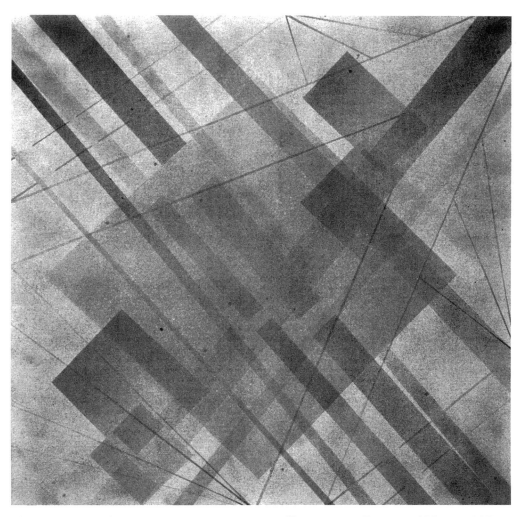

Fig. 24 Irene Vincent, *Tension,* 1975, Acrylic on Raw Canvas, 48"H X 48"W, Sold - Stanford Cohan's Collection

I contemplated the essence of the word "subtle." My boyfriend Kurt had once told me that I was as subtle as a train crash.

I asked, "What is that supposed to mean?"

"Of course," he said, "that's my point!"

Anyway, after looking up the word "subtle" in the dictionary, I thought that it was a good word to contemplate and to integrate its essence into my art. *The Random House College Dictionary* had several definitions of *subtle:* 1. Thin, tenuous, or rarified, as a fluid or order. 2. Fine or delicate in meaning; difficult to perceive or understand: *subtle irony. 3.* Delicate or faint and mysterious: a faint smile . . . and so on.

By using aspects of "softness," I felt I could gently intrigue the viewer into the world of geometric spaces. The raw canvas allowed the paint to soak into it. So the paint went through the whole gambit from creating surface layers to penetrating down into the fibers of the canvas. I mixed matt medium with the acrylics to soften them. And when I needed white, I used gesso to soften and matt the colors, like a white chalk.

I wanted to add another dimension of thicker paint to the spray paintings. The first textural paintings were too gaudy for me. Then I decided to experiment with monochromatic colors, which are shades of gray. As a child, I found growing up in the gray days of Rochester depressing. I wanted to overcome my psychological dislike of the color gray, so I searched for the beauty in gray. I found that different subtle hues of gray sparkled near one another. Also, gray placed next to a pure color made the pure color appear brighter.

Fig. 25 Irene Vincent, *Atmospheric Tension,* 1975, Acrylic on Raw canvas, 48"H x 48W

These next paintings were a result of this new process. In individual jars, I mixed monochromatic colors with the matt medium and water. I taped off some areas and sprayed them with subtle layers of color. On other parts of the canvas, I poured down thicker, semi-transparent hues of gray, and then with a long flat piece of rubber, I squeegeed the paint inside the taped geometric shapes. I let the area dry and then painted another layer on top. A certain magical quality was created when color showed through color even when they were muted. The viewer's eye searched for depth.

Entering these paintings into a show, I needed to title them, always another interesting part of the process. One evening before sleeping, I asked the universe for titles. The next morning upon waking, the titles came to me. The titles were *Blue Time, Earth Rock, Soft Mood Movement* and *Space Myth*. Two of those paintings were chosen for the Coconut Grove Gallery show.

In the painting, *Construction in Outer Space* (see fig. 30), I moved towards more color and I depicted a deeper atmospheric space than I had in the other paintings. So through geometric imagery, I developed a technique to express quiet movement, softness of line, silence and a universal harmony.

To my delight, the geometric abstracts became a surreal world of their own. As I painted them, I felt myself entering their spaces. At times, in my nighttime dreams, I walked through these abstract spaces as if they were landscapes. I became aware of how designing paintings in my mind (daydreaming) was the same as a researcher working on his inventions in his mind. I realized that focused daydreaming was underestimated. Both day and night dreams are the birthplace of creation and invention.

Fig. 26. Irene Vincent, *Blue Time,* 1976, Acrylic on Raw canvas, 48"Diameter

Fig. 27 Irene Vincent, *Earth Rock,* 1976, Acrylic on Raw Canvas, 48" Diameter

Fig. 28 I. Vincent, *Soft Mood Movement*, 1977, Acrylic on Raw Canvas, 48"H x 48"W

Fig. 29 Irene Vincent, *Space Myth*, 1977, Acrylic on Raw Canvas, 48"H x 48"W

Space Myth reminded me of a constellation in the sky.

Fig. 30 Irene Vincent, *Construction In Outer Space,* 1976, Acrylic on Raw Canvas, 48" Diameter

At that time, FIU did not offer MFA Degrees, so I just kept taking classes even when I had enough credits for my BFA. During my last year there, the painting professor and jewelry professor put me in charge of their classes as an assistant when they needed to go to a meeting or a seminar. I felt honored to teach.

Meanwhile, Ron graduated from the University of Miami. We grew tired of our flower business. We researched several other businesses to own and operate. Ron's father, Stan

loved Southern California. Stan had bought clay sculptures and Native Indian Jewelry from Zia Jewelry in San Juan Capistrano, California, informing us the store was for sale.

Stan said, "Irene, since you have been studying jewelry, your knowledge will help you to figure out that part of the business. And Ron will be able to figure out the business aspects. You two could do well. What do you think?"

Ron and I looked at each other with happy faces saying, "Yes!"

I said, "How do we start negotiating? Tell the owner that we want to come see the business."

Stan said, "Wow, I didn't realize that you kids would be so willing to move."

Ron replied, "Irene and I had visited Laguna Beach and Southern California on our way to visit Hawaii. We already decided to take any opportunity that looked promising as an excuse to move out there."

Still looking surprised, Stan said, "Your mom and Maurice moved to Florida to be with you. Gail and I moved here."

I said, "Well, Stan, how about coming to California with us?"

Ignoring that question, Stan said, "Let me see if I can help you kids get a business."

I informed FIU that I was ready to graduate. I officially graduated in 1977 with honors and way more than the required credits for my BFA Degree. Ron and I sold our flower business in Miami. We used that money along with a small loan from Stan to buy the small Native American jewelry store in San Juan Capistrano, California. We left Miami and traveled to sunny southern California.

En route to California, we visited Native American Jewelry wholesalers in Albuquerque, Santa Fe, and Gallup, New Mexico. Then we visited wholesalers and shops in Sedona, Arizona. From this trip, I became fascinated with the spirituality of the Native American Culture and with the beauty of the land. We arrived at our new apartment in San Clemente just as the moving truck was pulling up to the front door.

Chapter Four

California: New Beginnings, Painting Feelings

Ψ

California: Moving Towards Expressionism

*M*uch of my time was now spent with Ron building the jewelry business. We worked long days the first year. It was challenging, because Native American Jewelry had run its course as a fad. A lot of the jewelry sold to us with the business was of lesser quality. I told Ron that quality jewelry would always sell. People will always pay for the essence of *quality* in something. We needed to put on sale all the items we didn't like or that didn't match our standards. Then we'd only purchase well-crafted jewelry. We slowly figured out what appealed to our clientele.

I continued to paint in the evenings and on my one day off each week. After painting the geometric series with its measurements and preciseness, my soul longed to experience freedom and chaos. It was during this time I created my organic free form stain paintings on raw linen canvas.

I mixed acrylic paint with polymer medium and water to various thicknesses and put it in jars. I stretched the raw canvas onto 4-foot by 4-foot stretcher bars. My new painting technique involved pouring the liquid paints onto the canvas and brushing the paint around to create forms and puddles. Then I let the paint sink into the canvas and dry. Sometimes I sprayed the canvas and the paint with water so the paint fused out from its edges. It was much like the way some water-colorists paint. I loved my new freedom of expression, a

glorious release from the structure of the business world. The paintings *Deep Sea Tension* and *Wild Flower* were created using this technique.

Fig. 31 Irene Vincent, *Deep Sea Tension,* 1978,
Acrylic on Raw Linen Canvas, 48"H x 48"W

Fig. 32 Irene Vincent, *Wild Flower,* 1978, Acrylic on Raw Linen Canvas, 48"H x 48"W

<center>Ψ</center>

Goodbye Daddy: Hello to Marriage

After a stressful day at work, I took a long hot shower to wash away the day's pent up emotions. Customers often abused their jewelry and then demanded that it be fixed for free. No matter how much advice we gave on its care, written or in person, some people expected it to wear like a chunk of steel. These people came into the store, yelling and screaming that their jewelry did not wear well. I got ulcers of the stomach from trying to please and cope with the insanity of the public.

After the shower, I flopped upon the bed to rest before cooking dinner. I told myself, *Irene, you have to focus on all the wonderful people who come through the store. People come in and tell you their travel and life stories. People come from all over the world and tell you about the political climate of their countries. The faithful clients bring you gifts. You are earning a living. Be grateful.* That was my pep talk.

I thought about my dad living outside of Rochester. He had wanted to leave the city to move to a place closer to where he was born and to be near a lake. During my last trip to Rochester, I helped him to move to such a place. I thought about how he might be lonely there. Suddenly, I felt a strong urgency to call him.

I said, "Hi dad, how are you? It's Irene."

"I'm doing okay, he said. "But my legs seem to hurt a lot these days. I hate this house I'm renting. I've got to get out of here. It's going to kill me. I fell down the other night." The frustration in his voice rippled through the phone wires.

"What do you mean by that?"

"The hall way floor on the way to the bathroom slants sideways and throws me against the wall."

<center>126</center>

Bewildered, I said, "Maybe I could help you move somewhere else, the next time I come to visit you and the family."

"I got your present in the mail. Irene, you don't need to buy me presents. Save your money."

"Dad, I'm finally earning some money. I want you to know that I'm grateful for you helping me during college, when I needed it the most."

Changing the subject, I said, "I still remember how you took Ruth, Ed, and me out to fun places on Sundays. I can still smell the aroma of the delicious meals you cooked for us on our Sunday visits. I can still taste your home fried potatoes. Sometimes you cooked us fresh fish that you just caught. Do you remember that, Dad?"

"Yes and I also remember you being upset when I cooked you rabbit," he said. "But, you ate it anyway. And the same went for the deer."

"What do you like about hunting, Dad? Don't you feel bad about killing the animals?"

"Irene, I only catch a deer every six years. Then I eat it. Most of the time I just like sitting in the bushes mimicking the sounds of the birds. I like watching the animals. It gives me an excuse to be alone and sit in the woods. It's so peaceful."

"So, that's how you were able to make all those pretty bird sounds? I often wondered about that. You actually taught me to appreciate nature. I remember when you took us to the zoo and for hikes in nature on the nearby trails. I loved playing in the tall grass, while you fished in the pond. I still remember one Christmas when you gave me a Tiny Tear doll and you put a quarter in her little coat pocket for me. That made my doll even more special. I just want you to know . . . I love you Dad."

"I love you, Ireenie," he said.

"Please take care of yourself. It was fun talking with you about old memories and I'll call you soon. Bye Dad."

"Thanks for calling me. Irene, I love you. Bye."

After the phone call, I felt happy that I had called him. At the same time, I felt a foreboding that he may need help.

The next morning, as I was getting ready for work, my mom called and said, "Irene, I've bad news. Your dad died last night."

I fell into a state of disbelief. "Mom, how is that possible? I just talked with dad last night. Who told you that he's dead?"

"Your Aunt Ruth went to his house this morning and found him dead. They think his liver quit. Anyway, your sister Ruth is going to help take care of his funeral. Can you come home?"

"Of course, Mom. I have to go to work right now. I'll call you back later today. I love you. Bye."

"I love you, Irene. Bye."

Crying, I looked up and said, "Thank you God for letting me share fond memories with him." In that regard, I felt complete. I prayed for his soul. I flew to Rochester to go the funeral, which my sister Ruth arranged.

Up to now, I hadn't realized that my dad had been a type of anchor for me. Knowing that he was there for me had given me a sense of security. I now felt lost.

Meanwhile, Ron and I had been living together almost seven years. We both had been working many hours building our business. We had shared wonderful vacations to Greece, New York City, Columbia, Hawaii, Tahiti, and Jamaica. Ron loved beaches and I was grateful when there were art museums to visit. Whenever a trip entailed a stop over in New York City, we stayed there for a few days so I could go to the museums and art galleries.

A short time after my dad died, I said, "Ron, I feel very insecure. I have a life with you. I love you. I'm working hard. I think that I'd feel better if we get married."

Ron said, "Okay, then let's get married."

Neither of us wanted to have a fancy wedding. We decided to get married and then tell our families. It happened that Ron's dad, Stan, showed up for a surprise visit.

So Ron broke the news to him, "Irene and I have decided to get married next week."

Stan said, "Why don't you kids get married tomorrow, so I can be here for your ceremony?"

Ron said, "Alright, but we'll have to figure it out. It'll be nice to have you with us."

I called a Reverend out of the yellow pages and we got married the next day. It was a small impromptu ceremony at a park in San Clemente overlooking the ocean below. It was May 1979.

Soon after Ron and I were married, his mother, Dolly helped us buy a small two-bedroom condominium in Dana Point, California. Ron used a niche in the wall as his office. I used the extra room as my art studio. When I painted something extra large, I used the two-car garage.

Ψ

Search For Artistic Community

Meanwhile, I felt lonely, being without an artist community. I began asking my jewelry store clients where I might find a figure-drawing class or drawing group. I took a painting class at the University of California in Irvine because I wanted to pursue my Masters Degree in Fine Art. A Professor in the art department at UCI told me that I needed to get to know the art professors. I took a painting class, but the professor was rarely there. I applied that year, unsuccessfully, but was told not to feel bad because they only chose two students out of two hundred candidates. After that, I decided it was too difficult to pursue my MFA, especially since I already had a full time business. I still felt no connection to an art community.

A jewelry customer told me that the Laguna Beach School of Art had half-day figure drawing and painting classes. I wanted my figure drawing to become more expressive and

powerful, so that I could paint the political mural ideas brewing in my mind's eye. At the art school, I met the perfect mentor and drawing teacher in Artemio Sepulveda. According to Shifra M. Goldman in her book, *Contemporary Mexican Painting in a Time of Change,* Artemio had previously been part of a group of artists in Mexico called the Nueva Presencia Movement, members or supporters of this group were, Corzas, Coronel, Munoz, Ortiz, Sepulveda, Gongora, Gonzalez, Capdevila, Messrguer, Delgadillo, Lopez, Xavier, and Luna. Between 1952 and 1955, Sepulveda studied under Carlos Orozco Romero. When Orozco Romero retired, he invited Artemio to work with him and teach private classes.

I was so moved when I saw Artemio's large expressive pastel and charcoal drawings. He captured a person's character and soul in his drawings. Some of his images mirrored his own gentleness, yet I always saw and felt an underlying suffering in the figures portrayed in his art works. Sarcastic humor also prevailed in many of Artemio's works.

I understood the source of Artemio's insights and inclinations. He said that his parents were loving and kind. Raised in poverty, he was sensitive to the suffering of others. Still, I felt him a bit too harsh in his depictions of his portrait clients, especially wealthy clients, though, I knew he was coming from the truth of his personal experience.

While viewing one of Artemio's mural-size family portraits in progress, I hesitated. "Um, Artemio," I said, "that little boy looks very mischievous, like a little devil man. Have your clients seen their family portrait in progress?"

Artemio said, "His parents liked this image of their son. In fact, they said that they loved it."

Giggling, I said, "I'm glad that I don't have to meet the young boy."

Artemio was the perfect mentor for me going into my new period of expressing my emotions. I had already experimented with free form stain painting, giving myself a new flowing freedom of expression. I purchased books on Siqueiros, a famous Mexican Political muralist, Kathe Kollwitz, a powerful German Expressionist, and another book on the German Expressionist's movement. I felt a surging of emotions that I wanted to explore

130

through drawing and painting. And now, I had met my mentor. Artemio told me that he had modeled for Siqueiros, who had been one of his mentors.

Under Artemio's tutelage, I had a major breakthrough in my drawing.

During Figure Drawing Class, Artemio often said to me, "Irene . . . feel as if your pencil is following the contour of the model's muscles. Feel how the model's muscles are falling. Feel the tension and twist in the model's body." That word "feel" created empathy between the model and me. That empathy created a drawing alive with emotion.

While teaching, Artemio used the classic book, *The Natural Way To Draw*, by Nicolaides. His figure drawing and figure painting classes were both very experimental and classical in technique.

Fig. 33 Artemio Sepulveda

Fig. 34 Artemio Sepluveda and Irene in Laguna Beach, CA.

The following drawings (fig. 35 – fig. 41) were made during the years 1978-83.

Fig. 35 Left - Irene Vincent, 10 Minute Charcoal Drawing of Artemio, 24"H x 19"W

Fig. 36 Right - Irene Vincent, Charcoal, Gesture Portrait of a Model, 20"H x 18"W

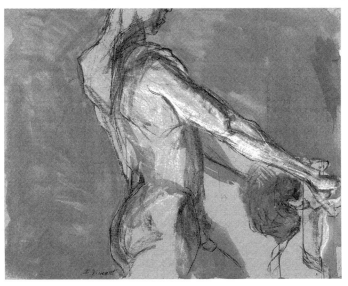

Fig. 37 Irene Vincent, *Man Fighting Man,*

Charcoal, Ink & Chalk on Brown Butcher paper, 30"H x 38"W

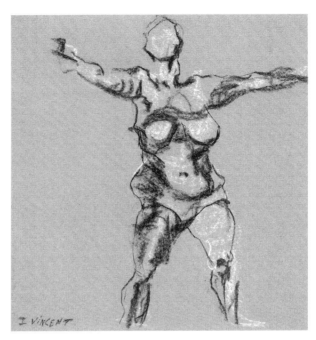

Fig. 38 Irene Vincent, *Gesture of a Woman*, Charcoal Drawing, 24"H x 22"W

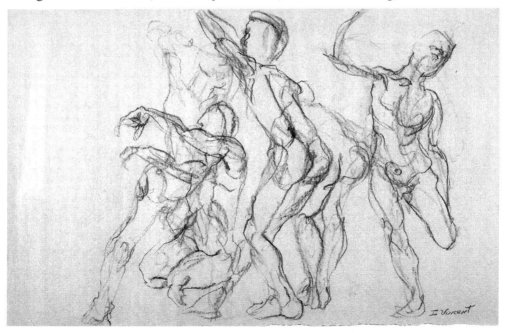

Fig. 39 I. Vincent, Gestures - *Figures in Movement*, 10 Minute Charcoal Drawing, 31"H x 44"

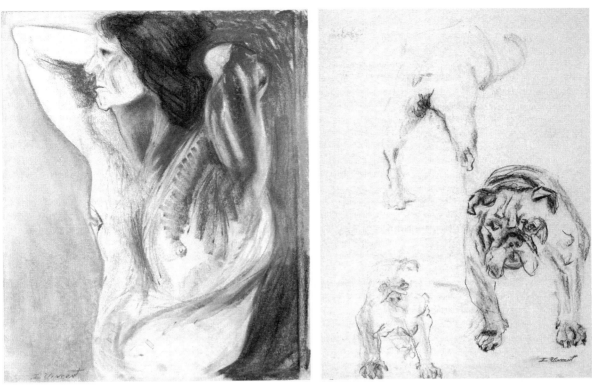

Fig. 40 Left - Irene Vincent, *Indian Man,* Pastel on Paper, 29"H x23"W

Fig. 41 Right - Irene Vincent, *Bull Dog,* Pastel on Paper, 44"H x 34"W

Ψ

Second Near Death Experience Stimulates Artistic Passions

At age twenty-seven, in the summer of 1979, the angels once again, catapulted me into that near death realm. The evening air was an unusual eighty-six degrees Fahrenheit and very balmy. In order to endure the heat, I was naked. I thought of ways to cool myself.

In the refrigerator, I saw half a melon. I thought, *now that should help cool me down.* Using the only clean large tablespoon available, I ate it as I watched television. The film showed starving people in Africa. Empathy filled my soul and tears flowed down my face,

blurring my vision. I felt guilty for eating my melon. Within a split second, a large of a piece of melon stuck in my throat. I ran to the kitchen sink, squeezing my throat and gagging in an effort to get it out. The melon kept sliding around inside my windpipe.

Should I try to run and get help from the neighbor, I thought. *I can't do that! I'm naked! Oh God, I'm going to die naked!* All of a sudden, once again, my life passed before me as a movie. I saw decisions and promises I had made to God to give some kind of gift to the world, and to help bring peace into the world.

In my mind, I said, "God, please don't take me, yet. I don't want to come back to earth again. Yes, I still need to give some kind of gift to humanity. I need to stay here, now. I want to live to be a healthy one hundred years old and then leave this place for good." To my amazement and relief, the melon slipped down my throat. I was able to breath again.

This life reviewing experience renewed and intensified my commitment to my art. I also renewed my commitment to run the jewelry business more efficiently, so I could afford more time to paint. I started to get two to three days off a week in which I could pursue my art. At that time, I had a lot of ideas for political art. By reflecting upon societies' problems, images for paintings came to me. I painted these images to shock the viewer into awareness, to give them insights into solving issues and taking humanitarian action.

I decided that when I did my figure drawing and painting, I would focus on exploring human emotions and feelings. These paintings acted as a reflection of my inner emotional landscape. In addition, I considered these paintings as studies for my future political murals. A powerful self-transformation was brewing, as I contemplated my life in American culture.

Many of my paintings were acrylic and or charcoal on large sheets of brown butcher paper. Usually a model was posing. I started by feeling empathy for the model. I wanted to capture some of the model's prominent anatomy. I let my being well up with emotions by thinking about the energy and movement in the pose. In my mind's eye, I visualized the

charcoal twisting and twirling on the paper. Then I let acrylic color and brush strokes channel through me, sliding across the paper, forming the image.

Often, I resorted to using my hands to paint with on the paper. I imagined the power, emotions, and convictions of artists like Kathe Kollwitz and Siqueiros, desiring that some innate truth reveal itself to me in the finished painting.

Fig. 42 Irene Vincent, *Thinking Woman,* 1980,
Acrylic Paint on Brown Paper, 34"H x 45"W

One day in 1980, I was painting a model, but when I saw the finished painting, I said, "This is *Thinking Woman*." I loved Rodin's famous sculpture of *Thinking Man*. I knew that he meant for *Thinking Man* to show humankind's capability to think and to reflect. And

137

yet, a rebellious part of me always felt that there needed to be a *Thinking Woman* counterpart. I wanted to honor and acknowledge the "thinking" quality for woman. Soon after, I learned that yellow is the symbolic aura color for the "thinking element." I thought how appropriate it was that the female figure is immersed in yellow.

Soon after painting *Thinking Woman,* I reflected upon some of the finer qualities of man. When a male model showed up, I painted him as *Dignified Man* (see fig. 43A).

When I started to paint *Lovers* (see fig. 43*)*, I summoned up a loving, passionate feeling. I contemplated the models. I painted with a 2" brush, swirling wide brush strokes together upon the canvas, dissolving and overlapping the human forms. I remembered a feeling of quiet intimacy while merging with my lover. While painting *Lovers*, I chose shades of, blues, pinks, and monochromatic grays, imbuing the expressionistic figures with a quality of "softness." I felt the figures melt together like my heart melts for my lover. Reflecting upon love opened my heart. And when I saw a newspaper's image of starving people, I drew *Four People in Hunger* (see fig. 45A).

Some of my 1981 paintings seemed to foretell my future interests in dream interpretation and astrology, such as *Dreaming Woman and the Moon* (see fig. 44) and *The Fortune Teller with Brass Legs* (see fig. 45). Since my first near death experience, at age 9, I'd been curious about the universe, especially dreams and astrology. Even so, I avoided astrology for a long time because of some innate fear of being burned at the stake. For me the astrologer was a Genie, invoked out of a brass lamp to reveal the future.

Fig. 43A Irene Vincent, *Dignified Man,* 1981,
Acrylic Paint on Brown Butcher Paper, 43"H x 28"W

Fig. 43 Irene Vincent, *Lovers: Grey Blue Lady and Pink Grey Man,* 1981,
Acrylic Paint on Paper, 43"H x 30"W

Fig. 44 Irene Vincent, *Dreaming Woman and the Moon*, 1981,
Acrylic Paint on Brown Paper, 30"H x 41"W

Fig. 45A Irene Vincent, *Four People in Hunger*, 1981,
Pastel on Paper, Approximate Size - 30"H x 40"W, Sold

Fig. 45 Irene Vincent, *The Fortune Teller with Brass Legs*, 1981,
Collage on Brown Paper, 30"H x 38"W

Part way through 1981, I no longer censored myself in expressing my true experience of society's self-destruction. Upon my newly declared liberation, my full expression burst forth, making it a prolific year.

I had a girlfriend named Gabriella take some Polaroid photos of me. Then I drew a group of small sized expressive charcoal drawings. As I contemplated these images, I thought . . . *I look depressed . . . how do I pull myself out of a state of depression? How*

does my "beingness" come back into life, naturally? From these contemplations arose *Introversion.* I began the drawing with a female in a somewhat depressive inward state, preoccupied with feelings and thoughts. The figure is in a fetal position inside a gray egg shape. This image is about the interplay of the microcosm and the macrocosm: of retreating within oneself to find answers and then going out into the world again to explore oneself in relationships.

Fig. 46 Irene Vincent, *Torment #1,* 1981, Blue Ink & Charcoal on Paper, 8"H x 10"

Fig. 47 Irene Vincent, *Depression,* 1981,

Ink, Charcoal, & Chalk Study on Paper, 8"H x 10"W

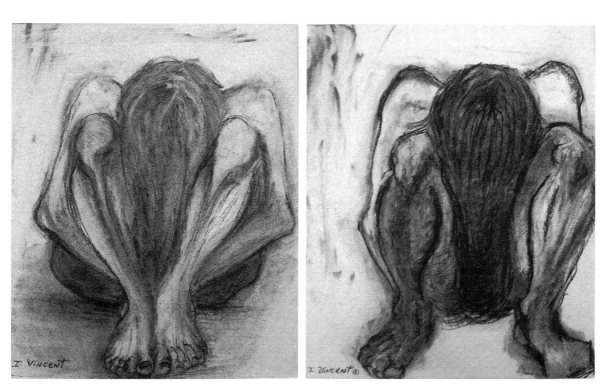

Fig. 48 Left - Irene Vincent, *Inward #1,* 1981, Charcoal Study on Paper, 10"H x 8"W

Fig. 49 Right - Irene Vincent, *Inward #2,* 1981, Charcoal Study on Paper, 10"H x 8"W

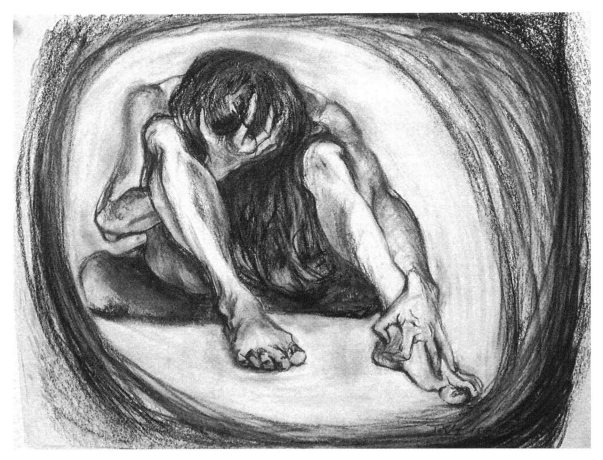

Fig. 50 Irene Vincent, *Small Study for Introversion,* 1981,
Charcoal on Paper, 10"H x12"W

In *Introversion* (see fig. 51*)* the figure is placed upon a magic carpet, one that can sweep her back out into life. As an artist painting from my own experiences, I recognized my own suffering, and then painted the solutions for self-healing. I became aware how images in artworks could integrate with our psyches and recreate our lives.

In the drawing, as the person is on her sad inward journey, she becomes fascinated with the light flowing through her strands of hair. The outer lines around the figure depict a larger than life view of what it's like to stare at the light and space between hair strands.

This fascination with beauty makes her want to return to life. The muse of beauty draws her out.

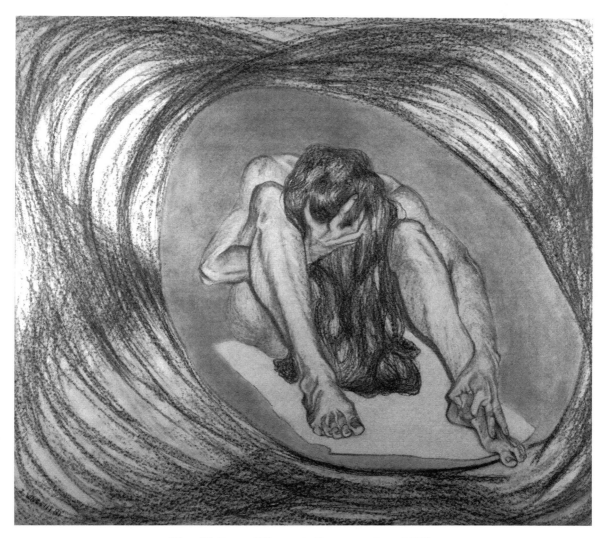

Fig. 51 Irene Vincent, *Introversion,* 1981,
Charcoal Drawing on Brown paper, 46"H x 51"W

Similarly, a rose is a "beauty muse": with the play of sunlight through its petals, its colors, its softness, and its alluring smell arousing my senses, it brings me out of an inward state of consciousness, fills my heart with love and appreciation. I drew *Introversion* to show a simple natural way back into a state of appreciation for "Life".

Soon after, my mom came to visit me. She was sad, very inward.

I said, "Mom, follow me, I want to show you my roses." I bent over to smell a rose, continuing, "Wow, smell this rose. Isn't it amazing how incredible it smells?"

Smelling the rose, she replied, "It does smell good. What kind of rose is it?"

"I don't know, but it smells like a peach. Mom, look at how the light shines through the petals. Is that pretty or what?"

Mom started to look at the other flowers around the yard. Just as I witnessed her transit out of depression and back into the world of life, she started laughing.

"Irene," she said, suspiciously. "What are you trying to do to me? Are you a doctor?"

"Mom, I wanted you to see that there is a lot of beauty in the world. You were looking too sad."

"Where do you get this stuff from?"

Changing the subject, I replied, "Let's go for lunch."

After finishing *Introversion*, I felt a new sense of being. This drawing was the quiet before my explosion of political expression.

Chapter Five

Explosion of Political Expression and Feelings

Ψ

Birthing Political Feelings

I often thought about the injustice of politicians making promises during their campaigns that they failed to keep once they were elected. From these thoughts was born the vision for *Aborting the Symbols of Promises Forgotten.* I read and studied the images in the book, *Kathe Kollwitz - Life in Art,* by Mina C. Klein & H. Arthur Klein. I studied Kathe Kollwitz's powerful lines in her stone lithographs and charcoal drawings. They emitted her heartfelt empathy for the needless suffering of the abused working class. Tears rolled down my face as I looked at her art. I prayed to Kathe Kollwitz's spirit to help me convey the message to inspire even one politician to keep his promises to the people and uplift their plight.

I cut images of politicians and the pope out of newspapers and magazines. I had Ron take some Polaroid photos of me. I studied my image. I laid out my pastels. I picked up a large blue pastel stick and mustered up all the emotions and convictions within me to unleash. The main figure flowed onto the paper. Then I drew in the politicians. I felt as though Kathe's spirit was next to me.

Shortly thereafter, I was invited to hang an art piece in a show at the Laguna Beach School of Art. Most men who first saw *Aborting the Symbols of Promises Forgotten* (see

fig. 52) on exhibit at the Laguna Beach Art School, looked at it and said, "Oh, it's woman giving birth to great men." Their voices rang with a pride.

When they saw the title, however, they knew there was more to the drawing. Most of the women who looked at the drawing told me they intuited its true meanings. After two days, I was asked to replace it with a subtler piece of art, experiencing my first censorship.

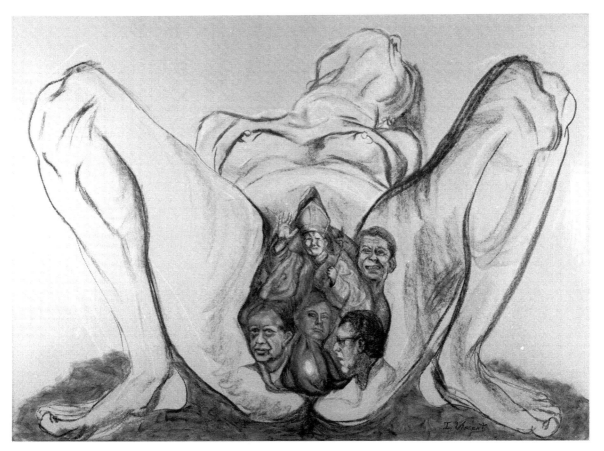

Fig. 52 Irene Vincent, *Aborting the Symbols of Promises Forgotten*, 1981, Pastels on BFK Rives Paper, 46"H x 51"W, Collection of Tony Mata

Aborting The Symbols of Promises Forgotten held other meanings. I felt some powerful political characters schemed to deny abortion to women in our country. I felt that

their reasons couldn't possibly be virtuous. I believed that these politicians really wanted to have enough low-income boys to form a future army. Logic beckons that if these politicians truly believed in pro-life, they wouldn't be able to risk this child's life by sending him off to war at 18 years of age. Furthermore, most middle and upper women could fly to another country to have an abortion. Automatically, the wealthy have choice.

A business acquaintance, Tony Mata, bought this drawing because he collected art with historical content. At the time, Tony said, "Irene, this image is interesting to me because of the fact that all of the greatness, sadness and decay of humanity emanates by and through the loins of women. And also, birthing parallels the nature of the earth and the universe itself, in the sense that birthing is the personification of the stars, moon, earthquakes, floods, volcanic eruptions, tornados, etc. These processes are both the beauty and the beast of mankind or something closely resembling it. Tony continued, "I also see it symbolizing women giving birth to great men."

" So," I said, "Tony, you can rename it *Woman: The Divine Chalice.*

With its new title, the image aims to impress upon "great men" the reminder that they all came from, and were nurtured in, a feminine womb. The feminine at its best, symbolizes a nurturing creative life force: "love", the ambrosia of the universe. If people choose to seek power, then they should seek to equally remember their "love" side.

In addition, this image caused me to contemplate the Immaculate Conception. I felt that, regardless if Mary was impregnated by the seed of the Divine Universe or by the seed of Joseph, the seed needed that sacred vessel of the feminine. The seed needed the chalice of the human woman to incarnate onto this earthly plane. God used a female's body or chalice to bring his/her light body into our physical density. The feminine force is a valuable life-giving, creative energy.

A woman often keeps her mate in touch with his heart, his compassionate side. We need the balance of our male and female energies for transformation of our soul, to unite us with the great oneness of the universe.

Ψ

Toxic Shock Syndrome

In 1980, I nearly died from Toxic Shock Syndrome. I was extremely angry that this was the second time in my life the Food and Drug Administration (FDA) failed to protect me. Years earlier, I had come close to death from using a Dalkon Shield, a contraceptive Intra Uterine Device. I felt the FDA was duping the American people. President Reagan, the president at the time, kept deregulating big business, which meant they could get away with more abuse to the public. Big business usually focused on profits, not compassion. *Homage to the Women Who Died of Toxic Shock Syndrome* (see fig. 53) was created to ring the alarm of buyer beware to the people of the US. In addition, I needed to release my anger and would no longer be silent.

In 1981, this environmental art piece was juried into a political art show. A day before the exhibit at OCCCA, the jurors decided it was "too political" to show. It was censored. I created the painting and the environment as both an homage to the women who had died or been affected by using Rely tampons.

I ask of you to pay attention to how your body feels. Is it tenser after a day of wearing a form of acrylic or polyester clothing? How does your body feel after a day in clothing made from cotton, linen or silk? Natural cloth feels good upon our bodies, while polyester builds static electricity upon our bodies and traps heat or cold. How do you feel after taking some prescription drug? How do you feel after drinking or eating food filled with chemicals? A function of art is to bring us into this sort of awareness.

I got my first supply of Rely Tampon in the mail, as a free trial offer. Shortly after my first use of Rely, I went to the doctor because I thought my blood pressure was low.

I said to the doctor, "I become dizzy when I go from a sitting to a standing position."

"Nothing seems wrong, he said. "Exercise more and put more salt in your diet."

The next month I went to the doctor again after my period.

Again, he said, "Nothing seems to be wrong with you."

In the third month, during my menstrual period, I was rolling on the floor at work with cramps. I called Ron.

"Ron, I'm extremely sick, I have to go home. I'm not sure I'll be able to make it home. You need to cover work for me."

Ron replied, "You can leave now. I'll be there shortly."

As soon as I made it home, I ran into the bathroom and pulled out the tampon. It had only been inside of me for an hour and it looked like something was growing on it, like a bacteria or mold. I panicked. I pulled a new tampon from the box. I cut the tampon open and it was filled with little pieces of plastic. They looked liked a by-product of some other product. I was shocked. I didn't want plastic in my body. *No wonder I'm sick*, I thought.

A high fever overcame me, so I hurried to the bed. I twirled down a tunnel of red and blue light. I thought I might die, but after three hours of hallucinating and sleeping, the fever broke. That was when I decided to check the dates on my doctor bills, finding they were all dated right after my periods ended. I turned on the television and there was a breaking news bulletin: Women dying from *Toxic Shock Syndrome* . . . caused by them using Rely tampons . . . more news at 11 p.m.! There was no more news about Rely until two to three days later. If I hadn't put two and two together, and had continued using the Rely tampons, I might have died. Newspapers reported the Toxic Shock bacteria had caused some woman to loose their toe tips, fingertips, and nose tips. After that episode, I tried three different times to use purely cotton tampons, several months apart. My period stopped immediately. Also my period that had lasted for seven days went to a three-day light flow cycle.

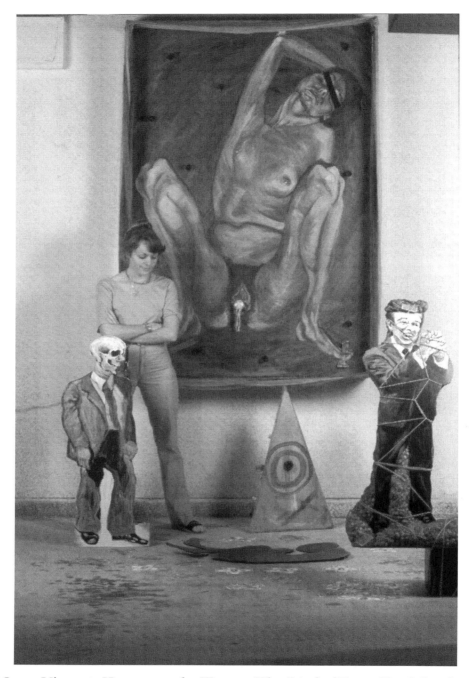

Fig. 53 Irene Vincent, *Homage to the Woman Who Died of Toxic Shock Syndrome,*
1981, Mixed Media Environmental Piece, Irene is in the Picture, Canvas is 72"H x 48W

In the painting, the main female figure on the canvas is oversized to emphasize the importance of the woman and the problem. Her blindfold symbolizes blind trust in authority.

The over sized paint roller in her vagina, stuffed with tampons is meant to shock people into realizing the problem. The red flashing lights poking through the canvas are saying "Warning! Take Care of Yourself." I glued the Rely Label from the box to the canvas as a reminder we need to take care of ourselves. I distorted copies of dollar bills by moving them fast under the scanner while the machine copied them. The distorted money spoke for itself. I had a skeleton man in a business suit smiling and looking down on the dark figure in a fetal position. He knows the product is "deadly," but he's eyeing the distorted money. The black fetal cutout on the floor symbolizes the businessman's dark, shriveled soul.

Since President Reagan's policy at the time was pro-deregulation of big businesses, I put him off to the edge of his podium to show man out of balance. I wrapped rope around the president to symbolize that most men in power are actually bound by those that sponsor their campaign. This money keeps politicians from doing what is *right,* what is good for the populace.

The triangular piece was a double symbol that women were the target market, and that business usually runs from a hierarchy. The dollar bill between her toes indicates the profit motive that started it all.

Ψ

Eddie

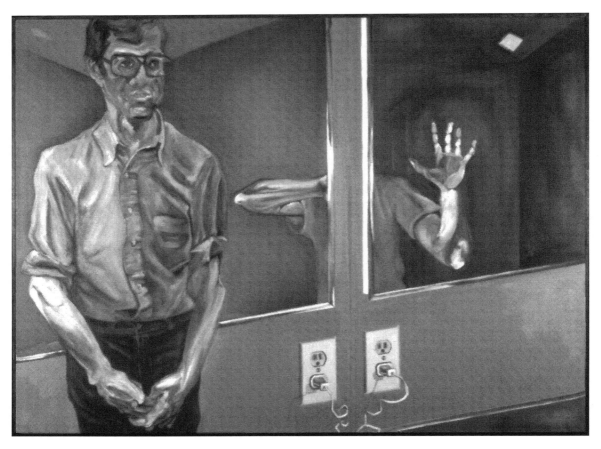

Fig. 54 Irene Vincent, *Eddie,* 1981, Oil over Acrylic on canvas, 36"H x 48"W

Eddie, my brother was 32 years old when he started to have a series of nervous breakdowns. Early on in school, he had been good at math, multiplication of numbers and counting money. However, he was born with an arthritic condition that made it difficult for him to walk. He life was filled with pain, prescription drugs, and their side effects. His fourth grade schoolteacher said he threw tantrums. She didn't want to deal with him, so she

put Eddie into Special Education, where he wasn't taught anything. Who knows for sure what occurred in Eddie's life.

The school system didn't have time for children like Eddie: they labeled him something I'd rather not put in writing. This classification hurt Eddie and thousands of similar children. My parents and family were told each year that Eddie wouldn't progress past a certain grade level. I thought, *of course, if you weren't teaching him anything, he probably wouldn't learn anything.* My family and Eddie started believing what they were told.

As Eddie aged, we called him Ed. When Ed was 33 years old, after one of his nervous breakdowns, I invited him to visit me in California and he accepted. As we drove around sightseeing, Ed and I had very intelligent conversations about politics, religion, and life.

"My God, Ed," I blurted out, "no wonder you're having breakdowns, you're very intelligent! Everyone is treating you as if you're stupid. You're depressed because they didn't teach you to read and write enough to be successful in life. You're just plain frustrated. If this happened to me, I would be too. The people around you have destroyed your confidence."

"Are you just saying that?" Ed asked. I could see Ed's facial expression change as a new revelation sunk into his consciousness.

"You're as smart or smarter than a lot of my friends." I took my eyes off the road just long enough to make eye contact with him. "In fact, because you don't write anything down, you've developed an incredible memory."

Silence filled the car. A deep sadness flooded my heart. *My God, he's suffered needlessly over these past years. If he weren't so smart, he would have had a better chance at being happy.*

Breaking the silence, I asked, "Hey, Ed, how about if I help you increase your reading abilities?"

"No. What if I can't learn to read better?"

"You can learn, Ed. You have to try. I believe in you. You'll learn fast. No one in the family needs to know I'm helping you."

"Maybe."

We both fell into silence.

Immediately, I bought some books and proceeded to coax Ed to read and write. He would try to argue his way out of each morning's session. However, since he liked to visit me in California, I bribed him: he could visit me for more than a week, as long as he let me teach him to read. Ed learned to read restaurant menus, road signs, and full sentences. He kept progressing.

Pretty soon the family was saying, "Ed can read. He's so smart."

Later on, when my stepfather was dying of cancer, I suggested that Ed take driving lessons, so he and my mother would be able to get around. Soon Ed learned to drive. The first time I was his passenger, he whistled as he drove the car. I saw that his newfound mobility gave him joy. I was moved to tears. I want to encourage others to hold faith and compassion for their family members. We are helping the world when we work on our own souls, when we help those who are close to us, and when we help other people.

I painted Ed's portrait, *Eddie* (see fig. 54) because I wanted to capture his essence in paint, his gentleness, sensitivity, sadness, and broken spirit, silently suffering in anguish. I painted the underlying colors vividly in his face and let them peak through the sadness of the blue gray colors. I depicted how he held his hands together in intense pain. I painted his arms with very purposeful hard-pressed strokes of blue grays, showing the strain in his muscles. The more vivid colors in his hands create a focus point and indicate tension.

Meanwhile, I creatively played with my camera and took pictures of myself in the bathroom mirrors. While looking through the camera lens, I saw myself spilt between the mirrors. It symbolized how I felt in helping Ed regain his self-confidence. I had to hold faith for both of us. Often, I felt that I was symbolically locked in the mirrors or locked behind windowed rooms trying to reach him. One room in the painting I painted neatly to

symbolize perceived logic. The other room, I painted more emotionally to symbolize that feelings had to come back in order to break free of restrictions. The hand pressing against the glass was asking for help. The figures behind the windows symbolize both my brother and me. This painting is a play on realities, illusions, and perceptions. Viewing the painting, I thought, *it is truly worth believing in people, truly worth helping them reach their higher potentials.*

<div align="center">Ψ</div>

Laughter

As a continuation of my explorations of feelings and emotions in 1982, I painted *Laughter* (see fig. 57). This image came through as I contemplated painting a portrait of my friend, Don Chase. While at the Laguna Beach School of Art, Don became one of my first artist friends, as well as a lasting friend. As a street fair artist, he had supported his family for years by painting daisies and whatever was popular in the moment. However, Don's brilliant intellect, along with his philosophical and poetic tendencies overtook his life's direction. He wanted to delve deeper into discovering his soul though his artistic experience.

Don had recently met his wife to be, Donna Hanna. Likewise, Donna, another highly intelligent and passionate artist, was studying to be a Jungian Sand Tray Therapist and a Marriage and Family Counselor. Though they were twenty years older than I, we shared an incredible passion for art, love for the beauty of nature, and search to evolve our souls.

We took many trips to art museums, lectures, and different places. Together, and sometimes with other artists, we often talked into the deep hours of the night about art and life. Our magical conversations were always filled with laughter.

At the art school, during breaks in the figure drawing class, Don and I commented on each other's drawings, talked and laughed. We threw wadded paper at each other, like little kids sometimes do.

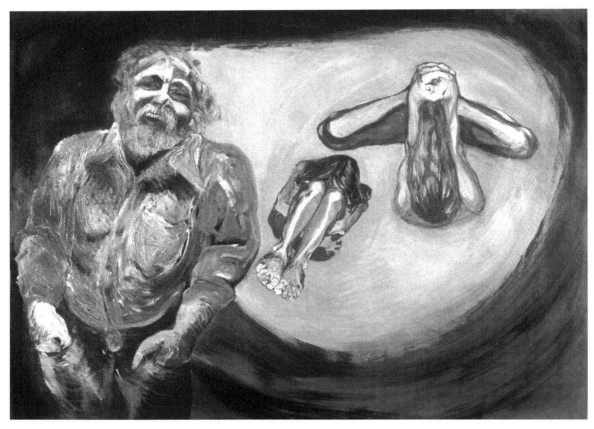

Fig. 55 Irene Vincent, *Laughter,* 1982, Acrylic Paint on BFK Rives Paper, 30"H x 41"W

In contemplating a portrait of Don, I wanted to capture his laughter, as well as convey his passion for art and life. Laughter was the main ingredient in sealing our friendship. I thought about how laughter takes us out of ourselves, out of our beliefs, and out of our worries. Laughter breaks us free. We feel like our minds are spinning. We are joyously suspended in space and time. Laughter is a momentary liberation from our self-made

boundaries. Laughter ignites our imaginations. So it is in that moment of laughter, we can heal our self-made limitations.

In the painting *Laughter*, I aspired to depict how I felt my mind would spin when we laughed, so I painted the two spinning figures. The postures of the two spinning figures were inward, since I was contemplative at the time. The color yellow symbolizes the intellect, indicating the figures are caught up in their minds. I used bright colors to show the happiness of laughter.

Fig. 56 Donna & Don Chase NYC, NY

Fig. 57 Don, Donna, Irene, & Donna's Father, John

Ψ

Sense of Timelessness

At this time, Ron and I started playing tennis, a game we could play with his parents when they came to visit us. Little did I know that tennis would increase my ability to figure draw. There was some kind of correlation between the eye-hand coordination of staring at the ball coming towards the tennis racket and striking it, with the eye staring at the model and capturing the image on paper. As I played tennis, I saw my figure drawing ability rapidly improve.

Another mysterious event occurred one-day while I was playing tennis. I entered a magical zone of timelessness. In slow motion, I perceived the ball coming toward me, then my racket hitting it so perfectly. The feeling was awesome.

Once again, I thought, "What is the essence of time?"

A few days later when I was figure painting while observing a live model, I again went into that zone of slow motion. The painting flowed magically onto the paper. I was amazed, realizing this was a zone frequented by many a great athlete and artist.

<div align="center">Ψ</div>

The Unknown, Being Overwhelmed, and Empowered

Around that same time, in 1982, I explored the colors blue, white and gray in a series of small figure studies. I spontaneously painted *Seated Male Facing The Darkness*. This image touched my psyche in that the colors of the man and the background seemed to blend. The thick white curving brush strokes over the gray background made it appear curved, almost spinning. The figure on the blue circle both floated and merged with the space.

In all of my artistic images, I saw my reflection, just as one way of interpreting dreams is to see yourself as all the characters in your dream, good and otherwise. The figure in *Seated Male Facing the Darkness* (see fig. 58) is symbolic of my inner self, facing the unknown, the night, and its shadow, as well as the mysteries of the universe yet to be discovered. In facing the darkness, one is willing to contemplate and take on the challenges that life brings.

I have heard creative people claim an overwhelming period in their life can make for heightened productivity. I'd like to hope that enthusiastic periods are just as productive. And yet, I have to admit that my overwhelming year was an extremely productive year.

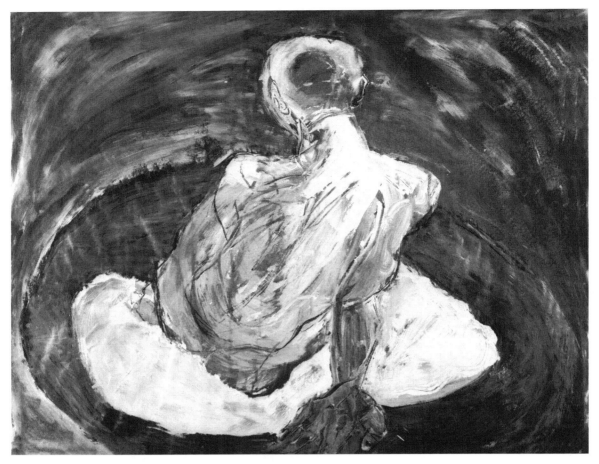

Fig. 58 Irene Vincent, *Seated Male Facing The Darkness*, 1982,
Acrylic on Paper, 32"H x 39.5"W

This next painting, *Man Being Engulfed* (see fig. 59) channeled feelings of frustrations from the two pieces of art being censored as well as some of my business and my life struggles. I started by flinging liquid paint from jars onto a huge piece of raw canvas lying on the floor. Then I swished some of the liquid paint around with brushes. This almost reptilian human form appeared on the canvas. I used my own handprint for the one hand reaching up to breakthrough the surface. With the sole of my foot covered in paint, I

stepped on the oversized head, leaving my footprint. All my emotions flowed through the paint onto the canvas.

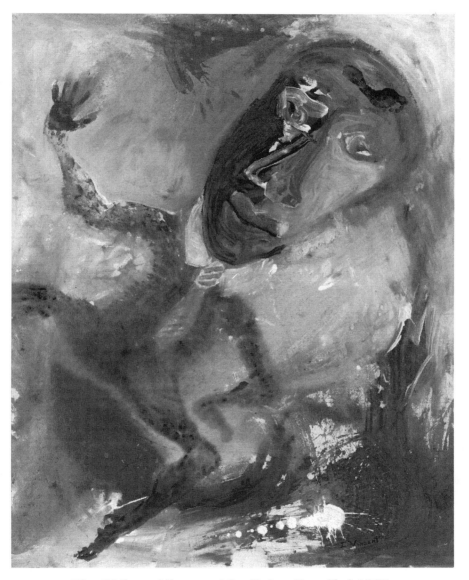

Fig. 59 Irene Vincent, *Man Being Engulfed,* 1982,
Acrylic on Raw Canvas, 69½"H x 54"W

This painting depicts a person overwhelmed by both inner and outer conditions. The man is barely staying afloat in the liquid chaos of life. He wears a tie to showing his bind to a corporate or traditional philosophy, which may or may not hurt the well being of his psyche. His head is oversized symbolizing he is thinking too much, out of balance and drowning in worry. His body is nebulous and reptilian. One of his hands is breaking the surface: a glimmer of consciousness. His enlarged head breaks the surface, however it is forlornly stamped with a footprint. For the powers he fears are ready to push him down.

From this painting, I realized that when I was overworked, over tired, or over stressed, I couldn't think clearly. The figure in the painting isn't sure how he feels about anything. I realized I needed to honor my mind, body, and spirit in order to find a refuge and to gain clarity in my thoughts and in my feelings. I found that when I honor my individual self, it's easier to honor my loved ones and then extend that love to others.

If a person can recognize this overwhelming state when he's in it, then he has the power to pull himself out of it. It only takes a shift in one's thoughts to attain a state of clarity. Will it take a moment, or eons?

Often during the painting process, I went from doing a very loose expressionistic piece to a more planned and tighter piece. This especially occurred when I painted with oils over the acrylics. *Emerging Woman* (see fig. 60) was such a painting.

It was inspired by a beach trip in Hawaii. As I was snorkeling underwater, I observed a man in swim trunks floating around in front of me. His floating human form created an interesting shape that symbolized to me a sense of drifting in life or a feeling of limbo. As soon as I got to shore, I drew from memory.

In the painting, both figures are nude making it a more universal image. As I started to paint the image, I realized "my female self" wanted to emerge. She didn't want to let anything hold her back. She was willing to break through the fire on the water's surface. It was self-empowering.

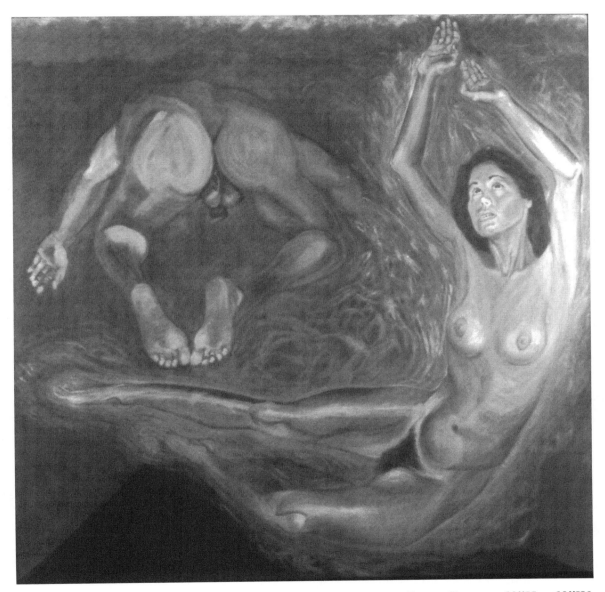

Fig. 60 I. Vincent, *Emerging Woman,* 1982, Oil over Acrylic on Canvas, 60"H x 60"W

Ψ

Mr. Joe Business and the IUD: Performance Art

During this time, I also experimented with other types of expression. One type was conceptual art. I had notebooks filled with ideas. For me, conceptual art was a type of mind game using words and exploring mixed media. It transmitted concepts into a powerful visual form. Even so, I felt that the process of making conceptual art was too cerebral, not heartfelt enough for me.

However, I did make a conceptual film of a group of multicolored balls rolling down a hill as I chased after them. Then, from above a freeway, I filmed the myriad of multicolored cars flashing by. I shot a group of multicolored balls floating in water. Then I juxtaposed multicolored moving objects and the colored balls. The film was about movement, color and the reactions that came from juxtaposing certain objects.

In furthering my self-expression, I studied performance art under Tom Stanton. He encouraged us to be very spontaneous in our creativity. In Tom's class, we performed one to five-minute impromptu performances, as well as fifteen-minute preplanned art performances. My best performance was a fifteen-minute one I worked on for several days, called *Mr. Joe Business and the IUD*. I had an audience of about forty people.

The basic plot was that Mr. Joe Business was going to manufacture IUDs, plastic birth control devices, despite knowing that the IUD-Dalkon Shield had many horrible side effects, including death. It was a small plastic device with prongs on the edges that kept it from falling out of the woman's uterus. These pointed prongs dug into the uterus, scarring tissue and causing infections

I was eighteen years old when one was inserted into me. I was told that it was more natural and less harmful than birth control pills. It was horrible and painful and I almost died from it. Thus I created this performance to help alert women.

Fig. 61 Irene Vincent, Front View, Performance Art:

Mr. Joe Businessman and the IUD, 1982

The performance was surreal. I made a rectangular clear plastic box suit, in which I cut openings for my arms and my mouth. It was approximately two feet by two feet and three

169

feet high. It had tiny strips of tape at different distances apart to convey that I was in an old style TV set with unclear reception. Red oil showed through transparent plastic tubes that were sealed, coiled and hung on the side of the plastic box suit. The tubes conjured images of blood, hospitals and suffering. I hung a businessman's tie from the mouth hole.

I placed a triangle of plastic bubble wrap upon the floor and as Mr. Joe Business told his story; he tramped upon it, bursting the bubbles causing popping sounds that sounded like farts and gunshots. The audience laughed.

Fig. 62 Irene Vincent, Side View, Performing, *Mr. Joe Business and the IUD*

At the same time, I set up a movie screen made of strips of cloth. Parts of the projected picture would show up on the screen and parts on the wall behind the screen, depicting the split in Mr. Joe's consciousness, indicating duality in the business world. Along with that, taped commercials from radio and television played in the background. There was talk about your dream home intercut with talk about cockroach invasion and fumigation.

As Mr. Joe Business, I lowered my voice an octave. While my voice vibrated strangely inside the plastic suit, I said, "I came home early to take my wife out to celebrate all the money we'll make from the sale of Dalkon Shields. I'm so excited and she's not here. She left me a note saying that she's out shopping. I know women might get sick and die, but it's such a high profit item and it is after all FDA approved. Our company will make millions of dollars before there is any fallout."

Accidentally forgetting my next line for describing the Dalkon Shield, I said, "It isn't very costly to make because it's so small, therefore it doesn't use much plastic . . . why it's so small . . . it's about the size of a dustpan."

Catching myself, I shook my head, thinking a dustpan could be a foot wide.

The audience laughed and kept laughing. I held out my arms showing the end. The audience gave a long heartwarming applause. Afterword some women shared their own heartfelt stories with me.

A few weeks later, news was released that the company had hidden their previous test results in order to get FDA approval. The company was sued and filed bankruptcy. However, I heard that they wanted to sell Dalkon Shields to unaware women in third world countries. This news saddened me.

Performance art was a very wonderful and exciting medium, but I was already working full time in my business and painting continued to be my first love.

Chapter Six

Transformation from the Political to the Spiritual

Ψ

Shocked by

Why We Need More Weapons **and** *Missiles and Coffee Cups*
Shamanic Transformation: Political Art Includes Its Solution: Prayer for Peace

In 1983, I saw a news photo of a politician standing behind a group of microphones ludicrously asserting why it was economically imperative for the U.S. to keep stockpiling weapons. Thus was inspired my painting, *Why We Need More Weapons* (see fig. 63). At the time it seemed California's whole economy was based on making weapons and items for the defense industry. Many of the people that came into my jewelry store told me their livelihood came from the defense industry. They didn't necessarily think that building weapons was the way for humanity to proceed, but they were caught up in the economic cycle. A lot of people were afraid to discuss the tension mounting over a possible nuclear crisis.

Meanwhile, I'm thinking, "Why can't these people use their creative energy and thoughts to create an economy based upon something humane, life enhancing?"

During the process of painting *Why We Need More Weapons* I channeled my angst and sorrow of having been born into this misguided society. My first idea for the painting was to expose the politician who was justifying our need for war and weapons. The politician is revealed as a masked semi-naked person standing behind a transparent podium. He tried to

hide the truth, but the truth will be known. His face is masked with jeweled eyes, alluring but quite reflective and thwarting the light from reaching his soul. His jeweled eyes are hungry for material gain and power.

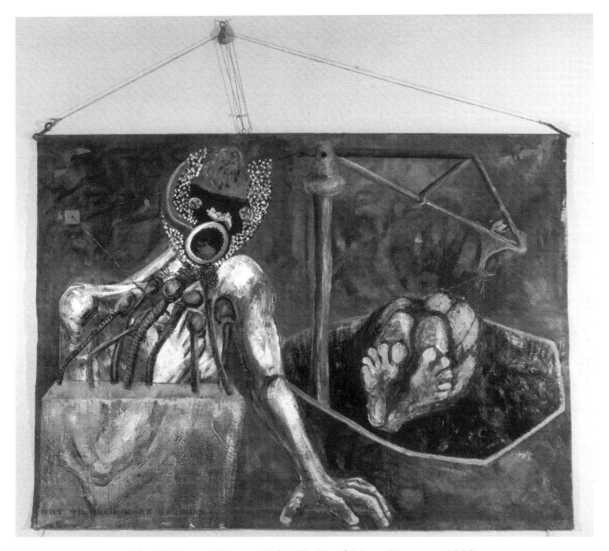

Fig. 63 Irene Vincent, *Why We Need More Weapons,* 1983,
Acrylic on Raw Canvas, 75"H x 78"W

A politician (a person) may have charisma --- a magnetic attraction that draws others to his side, but "attraction" isn't necessarily a good thing. I thought about how Hitler channeled the angst of the populace, knowing their frustrations, he expressed them verbally, upon feeling themselves heard, some people followed him. However, Hitler's own personal hatred led his followers down a misguided path.

In the painting, the masked figure's mouth is wide open and dark, full of untruth. The many microphones on the podium emphasize his stature and importance. His left hand leans heavily upon a green transparent film symbolizing suppression of the truth, green symbolizing truth. Full of self-importance, his right hand holds a rope connected to a pulley holding a bound body like a worthless piece of meat over a burial vat. Also in the vat are images of the material objects that someday won't even be important to those people who killed other people in order to obtain such objects. To emphasize this point, I devised a real pulley system from which to hang the painting.

The finished image was shocking even to me.

I thought, *Would this image help people move out of their material complacency into a more caring mode of consciousness?* What this image made me realize became "the essence" of the title of the painting: **Men Only Need Weapons In Order To Kill Other Men . . . There Is No Justification To Kill Another Being.**

Sometime later, while sitting at a café counter waiting for my lunch, I contemplated the inherent power of missiles. *A few people could wipe out all of humanity and possible destroy life on earth, as we know it.* My thoughts felt taboo. *Did any one even care to listen?* A major part of the California economy was the defense industry and most people were connected to it. During a moment of exasperation, I put my face in my hands, realizing I had made a mask image. Lifting my coffee cup to my face was almost like wearing a gas mask, creating memories of bygone war images.

From my thoughts in the café, *Missiles and Coffee Cups* (see fig. 64) was born. That night when I arrived home from work, I had Ron take Polaroid camera images of me

holding coffee cups next to my face in different positions. I painted the image of myself sitting at the counter with my hands cupped in front of my face. My hands are cupped around my lips, as if I'm calling someone in the distance to warn them.

And yet, because it's taboo to speak against the defense industry, the lips have a line over them. White is painted around the eyes to show they can clearly see the folly of this nuclear scenario.

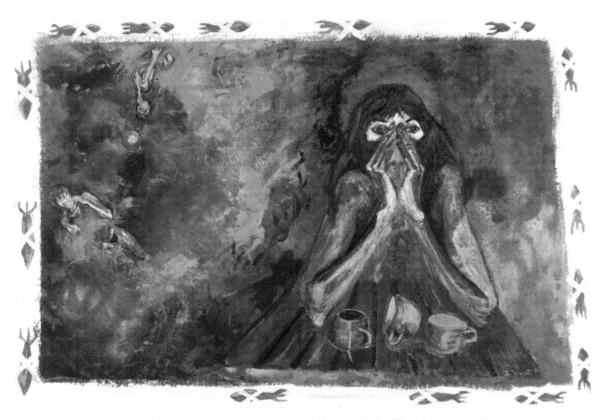

Fig. 64 Irene Vincent, *Missiles and Coffee Cups,* 1983,
Acrylic on Raw Canvas, 50"H x 72"W

The diamond-shaped image created in the space between the hands and the triangular shape between the arms in the chest area depicts an ancient goddess, a protectress. The green color in the chest area symbolizes new life.

The blue color in the green chest area is a spinal column appearing like it might in an x-ray. It has the double meaning: our bodies would become transparent from the radiation of a missile explosion; also more symbolically, if we were more transparent, our hearts would solve our nuclear dilemma.

The background symbolized outer space; with two floating figures drinking coffee. It is as if our thoughts are like a frozen dream film, floating through space and time.

Originally, I painted two large missiles in space ready to attack. With those missiles lurking in space, the reality of attack looked possible and very scary.

A thought came to me, *art doesn't need to just reflect the problems of the world. Artists have the power to turn the image into magical prayer and ceremony for peaceful solutions.*

With "healing intention," I painted out two large missiles that had been in the center of the picture. I added a white border around the edge of the painting to symbolize the Divine Universe's sacred energy surrounding and protecting the Earth. I put missiles in the border because they were real threats, but I painted an X over each of them in the white protective pure color. The X symbolized knowledge and intuition forming a pure wisdom, powerful enough to annihilate the missiles, protecting the planet. I felt such relief.

In 1984 *Why We Need More Weapons* and *Missiles and Coffee Cups* were both juried into a Political Art Exhibit by Michael Schnorr at Southwestern College in Chula Vista, CA. This was special for me, since it was a rare occasion in which I was able to show my political art.

The act of creating this painting, I realized, had been a ceremonious healing experience. Suddenly, I felt connected to the Shamanic tradition of healers. I thought about how I could no longer paint and reflect the problems of society.

I questioned the validity of my shocking images. My images were meant to shock the viewer into becoming conscious of the problems and moral dilemmas of society. I wondered if some perverted viewers might be relishing the images.

I asked God, "What would a powerful form of love look like, a love beyond the sentimental and limited bonds of family? What would an image of this love look like, an image that could extend out to humanity and beyond its boundaries?" I prayed, "Please help me to paint "solutions." Please help me paint "love." I now felt more empowered in my life and in my art making. These thoughts guided me on my new spiritual path.

For a long time, I had shied away from religions, wary of their self-righteous dogma, the idea that only their system could save my soul. Religious dogma separated me from others. To me, that was the opposite of "love." However, I decided to research the major organized religions of the world. While reading the book, *History Of Religions,* by Huston Smith, I discovered an affinity for Buddhism.

When I read new books on Buddhism and shamanism, my dreams became even more relevant and alive than they already had been. Once a week for a three-hour period, I participated in an art therapy workshop directed by my friend, Donna Hanna Chase. I already liked the symbolist and romantic artists, but now for me symbolism became even more alive. As symbols appeared in my art and dreams, I would look up their meanings as written in my Jungian Books of Symbols. I would contemplate which meanings held relevancy for my life. This process helped me to develop a greater dialog with myself.

Ψ

Emerging out of the Subconscious

After the shamanic experience of painting *Missiles and Coffee Cups*, I painted a more psychological piece, *Emergence out of the Subconscious*. As I stood back and looked at the

finished work, I felt it represented my perception of my brother Eddie coming alive. Yet I knew it was about my own self-awakening, too.

I was scared by shriveled figure sitting on the watery gravestone. It looked as if its body and consciousness are stuck in the collective unconscious. One part of the psyche is frozen and dead looking. The other part of the psyche is ready to celebrate life. It was symbolic of an awakening from the dark collective unconscious.

I was drawn to using copper paint in the celebrating figure as well as for the background. I had never used copper colored paint before in an art piece. I discovered that copper is one of the seven metals of alchemy. Copper was associated with the planet Venus and the ancient goddess Aphrodite. I was happy that the painting was infused with such a "love element" as copper.

Fig. 65 Irene Vincent, *Emergence Out of the Subconscious,* 1983,
Acrylic on Raw Canvas, 59"H x 68"W

179

<div align="center">Ψ</div>

Journey to the Heart

I was working many hours in my business when I painted *Journey to the Heart* (see fig. 66). I was realizing how competitive the business world was; I didn't think that it always brought out the best in people. Life felt like such a struggle at times. My heart felt like it had a black hole in it.

Fig. 66 I. Vincent, *Journey to the Heart,* 1983, Oil over Acrylic on Canvas, 48"H x 60"W

I felt love when I was in nature or viewing nature's beauty, yet I felt emptiness combined with a longing to experience something greater in this life. Expressing myself through art was the only thing that made me feel alive. After painting with color, I would routinely go outdoors where I would be freshly aware of all the colors. Now there was no longer a monotone green tree; for I perceived in it violet greens, yellow greens, red greens, orange greens and so on. Doing this increased my observance, my awareness. The act of making art filled my life with color beyond the canvas.

I was a businessperson and at the same time I observed businesspeople being greedy, losing sight of their humanity. I felt myself split between wanting to exist in my ideal world and having to exist in the competitive market place.

In *Journey to the Heart*, I imagined a couple's car breaking down in the desert. They carry their baby while walking down the road, looking for help. They meet a nomadic couple with their child.

On the ground, there is a blue outline of a large heart. I painted the nomadic couple and their baby standing inside the heart shape to symbolize that they stand strong in their hearts. Their life has simplicity to it. Also since they know themselves, they have only one face.

The businessman, on the other hand, has his foot on the edge of the heart. His other leg with his eagle talons hangs firmly onto his brief case, this being symbolic of his identity and way of life. He has three transforming faces. The first face is showing how upset he is with his predicament. He is fearful. The second face is masked and angry and looking toward the other man, wanting to show some sense of power. Finally, in recognizing the other man's innocence and centeredness, the businessman comes to his own centered peaceful self.

The wife also has one foot in the heart. She has two faces. The one face is insecure, unsure; she looks to her husband for security. As she sees the babies in their innocence joyfully reach out to each other, she becomes centered and peaceful. Only the babies have

shadows, symbolizing their innocent wholeness. This painting was cathartic for me: I identified more with the nomadic couple craving a simple life.

$$\Psi$$

Divorce

As I became more exuberant, more focused on my soul's path, Ron became intimidated and insecure.

Finally, I said, "Ron, I am leaving this relationship."

"Why?" He asked.

"When I tell you about my deepest dreams and my desires to decipher the mysteries of the universe, you interrupt my stories with jokes and nervous laughter. Your jokes frustrate me. I'm feeling that I can't share what I now hold dear to me. You just want to work all the time and talk about work. It gets too stressful and boring for me. A number of times, you told me to wait for you to go to an art opening and then you come home late and say that we'll go another day. I need an art community. I need friends. And furthermore, every time I tell you what I'd like to do in life, you kindly listen and then tell me that now isn't the right time. At some point, we'll get to what I'd like to do. Well, I've had it!"

I trembled, tears running down my face, their salty taste wetting my lips. Ron's own tears were falling.

Ron said, "Look Irene, you just don't mean this. We need to talk more about this. You're just being emotional."

At this point, I thought, *Oh my God! Here we go again.*

Tenderly, Ron continued, "Look Irene, think of all our good times. Don't give up on us. Does your friend Donna know a therapist?"

Doubting my decisions, I agreed to go with Ron to a marriage and family counselor.

After a few sessions, the counselor said, "Well, Ron, Irene has firmly made up her mind to leave this marriage. Do you want to work on making it an amicable breakup?"

Ron looked stunned, grabbed my hand and said, "We need to go!"

Once in the car and heading home, Ron said, "That man is biased since he knows Donna. We need to find an independent therapist. Will you go to one more therapist with me, Irene?"

Emotionally drained, I said, "Sure, Ron."

We went for several sessions to the next therapist. She talked with us together, as well as individually.

She finally said, "Ron, Irene has made up her mind. Do the two of you still want to run the business together? We can do value tests to see how you can better understand each other and divide your work day activities."

Ron and I agreed it would be good for us to help keep the business running. The business was like our child. It had taken a lot of time to make it successful.

At first, Ron said to me, "I'll only keep it going for one more year until we can sell it."

I said, "Well, you have to let me be part of the selling process."

He said, "Okay."

We agreed upon a selling price.

In the meantime, we separated. A few men got serious about purchasing the store. However, Ron, always found a way for me not to be at these negotiations.

I said, "Ron, those men are going to sense that we're getting a divorce because they haven't met me. If they lower the price, I'll buy your side of the business."

Every competitive bone in Ron's body straightened up and came to attention.

He said, "Why would you want to run the business? Do you think it could support two of us?"

I said, "There are no limits to the income we can earn. We just need to think outside the box. I think we could earn more money and get more time off work."

I had seen that wiggly expression on his face before. If he weren't so serious, it would be humorous.

Breathing in, Ron looked at me thoughtfully. "Alright, Irene," he said, "if those men lower the price tomorrow, I'll work with you for one more year."

We ran the business together for another fourteen years. With the help of the therapist, we decided that Ron and I would each be present in the store for three days a week. We would work together on Tuesdays for our business meeting with our employees for planning the next week's goals. Sometimes, after the meeting, one of us would go on a jewelry-buying trip.

I took care of developing the gold and gemstone jewelry part of the store. Ron worked on developing the Native Indian and Inlay Artisans part of the store. Once or twice a year we would go on buying trips together in order to give each other feedback on which types of jewelry to buy.

The business grew. We were quite successful and could afford more time off. I attributed our success to our mutual trust with money, to us being great creative sounding boards for each other, and to our mutual sense of responsibility. To this day, I still consider Ron as a confidant and friend.

Ψ

The Artist's Myth: Living in the Warehouse

After my separation from Ron, I moved into an 1800 square foot warehouse, exploring the artist's myth that one had a chance of being a successful artist, if one lived in a huge creative space. I must admit it was fun having a huge room in which to make a mess and create art.

However, I had to put up with the antics of the welders next door. I found I didn't have the same rights in a commercial zone as I did in a residential zone. The welders were accustomed to my space being empty and wanted it to stay that way. They played loud music all day and night. I couldn't find earplugs strong enough to block it all out. The noise would painfully vibrate through my body. At one point, they purposely left their car idling in front of my only entrance door, the car exhaust blowing into my space. They blocked my back garage entrance with boxes of product and steel parts. They were the neighbors from hell!

As if that wasn't torture enough, one night as I was going to sleep, I heard scratching and chewing sounds inside the bedroom wall. I dragged myself out of bed. As my heart pounded, I checked both sides of the wall. There were no holes in the wall that I could see. I jumped back onto the bed. I sweated as I pulled the sheet over my head for protection, as if that thin sheet was a great barrier to an intruder. I was so tired and exhausted that my imagination ran rampant. I questioned, *was it a ghost? What kind of animal was in my wall?*

The next evening, as I was sitting at my dinner table, a huge rat came scurrying into the room. Startled, he screeched to a halt! Both of our eyes locked and enlarged, as I jumped atop my dinner table.

Staring at the rat, I whispered firmly, "Please leave and don't come back, because I don't want to have to hurt you."

He scurried back through the wall. Shaking with fear, I put a wire-scouring pad into the hole. I didn't see the rat again. As I looked up at the ceiling, I asked, "Are there any more signs from God that I should get out of Dodge?" However, I had a nine-month lease, so I was going to try to endure it.

On the bright side, I met Robert, who had been participating in my friend's weekly Art Therapy Workshops. We quickly became friends and he moved in with me. Robert enjoyed art museums, intellectual movies, and traveling. At the time he was busy in college

studying for a degree in human resources. It was a great relationship, since he was busy studying and I was busy working at my jewelry business, making art, and participating in classes on my way home from work.

Happily enough, the space in the warehouse allowed me to work on several large paintings at once. My artist friends, Lois and Steve Bergthold, lived three units down from me. They held artists' meetings once a month, at which we would critique each other's art, share ideas, read poetry, and discuss the art world. They were my immediate community.

Fig. 67 Irene Vincent, *Enter the Dragon*, 1983-84,
Acrylic, Cheese Cloth, & Paper on Raw Canvas, 53"H x 69"W

186

Soon I painted *Enter the Dragon* (see fig. 67). Political and satirical images still came easily to me. I contemplated a problem in society and an image would appear in my mind. Entering this new realm of questioning, "What is love?" was scary to me. I wondered if any images would come to me. I wanted to help the world, but I realized I needed to help my family first. How could I help all the dysfunctional families out there if I couldn't help my own? How could I help my own family to be more loving, if I can't help myself to be more loving? What would a powerful form of love look like beyond the love of sentimental family groups, clans and tribes? The question of love took me to the core of my being.

Strangely, *Enter the Dragon* began as a self-portrait. The hands are raised in the air in a surrender position. I realized I had to personally transform my own being and soul in order to emanate greater love. The head took the shape of the dragon speaking in square shapes and diamond shapes, which represent logic and intuition. The dragonhead also symbolized to me that life itself was a dragon of experiences, challenging and fiery.

In the dragon's abdomen, the heart shaped opening symbolizes that, in entering the unknown, I'll be protected by my faith, knowing the core of the universe is love. I wrote the word "enter" in reverse as "retne" so I wouldn't get lost on the journey. As we enter the deep space within ourselves, we simultaneously enter the depths of the universe, and vise versa. The circles around the edges of the painting symbolize planets and moons as cycles of time.

In early 1984, I considered a new painting, large enough to represent my divorce. I thought of me walking off one side of the canvas and Ron walking off the other. We would both be waving goodbye.

However, I realized that I had no idea what he felt. I truly only knew how I felt. The divorce had been my choice and it was painful to be separated from someone I shared eleven years of my life. I realized I was giving up the great times shared with his family. However, my soul called to me. So the divorce image turned into *Journey of The Soul* (see fig. 68).

I painted it with acrylic paint, cheesecloth, sand and photos over stretched raw canvas. This image is representative of The Journey, our life's journey, *remembering* that one is a spiritual being. This artwork honors my spiritual journey as a primary event in my life. It depicts my illusions of feeling separated from the divine and at the same time it depicts I am *oneness*, merged in divine union.

At the top of the painting, the golden spheres represent time and space. In the upper right hand corner, the hand coming through the light symbolizes *Divine intervention.* I believe that The Divine is always ready to bring us into unity. The little photos of body parts symbolize the duality of the human psyche. If we feel or create conflicts in our minds or with others, then we perpetuate our illusion of separation. This feeling of separation is the root cause of suffering. This feeling of separation is the root cause of suffering.

The photos of the body parts sever the orange human fetal shape from the light blue human fetal shape. The fetal position depicts birth, a new beginning. Conversely, I had also seen pictures of bodies preserved in a bog curled in the fetal position. In that regard, the fetal position also seemed appropriate to symbolize the death of attributes and habits that no longer served the soul's journey to oneness. For me, the orange fetal form symbolizes death, the falling away of old habits and belief patterns that no longer serve my spiritual growth. These old habits, in the form of the orange body, are falling into the crucible, being transmuted into pure energy. The light blue fetal human is symbolic of the remaining Self being purified by the fiery light, and blessed with divine virtues.

As I used my own feet dipped in paint to create the footprints of the sacred circular path, I had to hold onto a stool, because I was slipping around on the canvas. Using my feet as an art tool connoted to me a conscious soul-searching act. This ritualistic act was a self-initiation.

Fig. 68 Irene Vincent, *Journey of the Soul,* 1984, Acrylic,
Cheese Cloth, & Paper on Raw Canvas, 65"H x 92 ½"W

The "Self" consciously walks the golden, mysterious path of Divine union. Inside the circular footprint path is a photo of a whole body forming a triangle within a circle, symbolic of the spiritual principle within eternity.

One of the powers of art is that inner processes become visible. When we see an image on the canvas that speaks to some aspect of our psyche, we become more aware of that aspect; if it serves our highest good, we are inspired. All of us are in search of love, truth and happiness. And when we consciously search for these divine qualities within and outside ourselves, we create and attract the vibration force that fills us with joy, peace, love, bliss, and grace, which we in turn emanate to others. And so, I say, "May this image

189

be a reminder to pull away from the narrow focus of everyday events to consider the Big Picture, the mysteries of the universe."

Fig. 68A Irene is posing in front of *Journey of the Soul* in 1984.

Epilogue

My next book, Part II of my Trilogy, takes place over the next five years. It starts out with me still living in the warehouse working on my sculptures. Sooner than my lease expired, I was able to find and buy my first home in Irvine, CA which felt like quite a feat since I had been a little girl from poverty, who at one time was too scared to even imagine a "dream home" for fear of it never happening. The jewelry business kept growing and all my spare time was given to my gaining knowledge of the self.

During these years leading up to 1989, my knowledge and experiences with dreams deepened, intertwining with daytime reality and my art. The adventures continued as I traveled to sacred sites and basked in their ancient spiritual energy. Spiritual teachers, shamans, yoginis, and yogis came into my life and dreams, bearing gifts of wisdom, healing, peace and bliss. I hope these stories inspire you to listen to your intuition and follow your dreams.

In the third book, waiting to be written, I will share stories of my meeting more yogis that take me into deeper meditation and on more adventures in life and in dreamtime. At the time, I contemplated and learned from books and teachers about my experiences as they were happening to me. As inspired by Swami Vishnudevanand and with initiations from him, Shri Shri Shri Shiva Bali Yogi, and other spiritual beings, with my whole heart and soul, I yearned to experience the Divine Cosmic Universe. Whether you just have begun your spiritual path or have been on it for some time, some of my stories may be a helpful guide and inspiration to you. And if you don't think about spirit much, it'll read as an exciting adventure story.

I still live in Southern California. I teach painting classes with spiritual intension and spontaneity, so that the participants open up their imaginations automatically. I am giving creative spiritual retreats, in which the participants practice present moment awareness,

open their hearts, minds and souls by learning to channel spirit through different mediums: dreams, journaling, contemplating, painting, and more. Channeling is a way of communicating with yourself, your higher self, and the Divine Universe.

I also continue writing and painting. I give talks on transformation through art, dreams and contemplation. And I give individual spiritual counseling sessions along with energetic healing. It's a pretty holistic session for I often season it with business consultation guiding you towards success in practical everyday life.

See Irene's Mystical, Visionary & Surreal Paintings: http://www.irenevincent

See Irene's Youtubes: http://www.youtube.com/user/artistvincent/videos

Irene's Facebook Page: https://www.facebook.com/IreneVincentAuthorVisionaryArtist

Follow Irene on Twitter: https://twitter.com/#!/IreneVincent

Irene's Blog: http://irenesmysticalmoments.blogspot.com/

About The Author

Fig. 69 Irene Vincent, Photo by Jesi Silveria

Education:

B.F.A. Florida International University, Miami, Florida, 1977

Major: Painting, Drawing; Minor: Jewelry

Laguna Beach School of Art, Laguna Beach, California, 1979 – 1981

Figure Drawing with Artemio Sepulveda, 1979 – 1983

Performance Art with Tom Stanton, 1982 and with Valerie Bechtol, 1983

Studied Mische' Technique with Prof. Philip Rubinov-Jacobson in Europe: 2002, 2003, 2004, & 2005

Studied Old Master/Magical Realism with Robert Venosa and Martina Hoffmann, 2006.

I have been teaching painting classes that open up the imagination and tap into spirit and intuition, such as "Painting Your Way To Happiness" and "Channeling Your Soul through Painting." 2000 to the present.

Scholarships, Awards, Society Memberships & Activities:

Fine Arts Tuition Merit Scholarship, FIU, Miami, Florida, 1976

Excellence in Art Award, FIU, Miami, Florida, 1977

Scholarship Award, Figure Drawing, Laguna Beach School of Art, CA, 1979

Woman Artists It's Time, Miami, Florida. Membership 1975 – 1977

Participated in Hanging Shows for Women Artists It's Time

Student Association for Art, Florida International University, Miami, Florida, 1976

Participated in Hanging Student Shows, 1976 and 1977

C.G. Jung Club of Orange County, CA 1984 to 1987

Jungian Dream Analysis Study Group, CA 1984 – 1986

Orange County Center for Contemporary Art, CA (OCCCA) 1985 to 1987

OCCCA/Director of Exhibitions, 1986-1987

The Inside Edge, CA (New Age breakfast lecture club) 1986

Honorable Mention - Cash Award for "Cat Man" sculpture, Irvine Art Center, CA, 1988

I personally met with, studied with and had yogis stay in my home: Swami Sivananda Radha, Swami Sahajananda, Swami Shantanand, Swami Vishnudevanand, Shri Shri Shri Shivabalayogi, Maharishi Vetarthri, etc. I had Initiations by the Dalai Lama, 1988 to present.

Member of SAI (Self Awareness Institute) 1989 – 1992

Studied ancient cultures, visited ancient sites and studied ancient symbolism, art and spirituality, 1988 to present.

Studied Astrology since 1990, member of AFA (American Federation of Astrologers) 1992 to 1994 and a member of SCAN (Southern CA Astrological Network) 1990 to present

I have been a member of "Light Bearers" an Orange County Branch, 2008 to 2011. My life partner, Ron Figueroa and I started a MeetUp Group called CARMA – Center for Awareness, Releasing, Manifesting, and Awakening. "Healing occurs when we combine our energies and open our hearts to the Universe." Orange County, CA, 2011 to present.

Publications:

The Miami Art Scene, June 12, 1976

OCCCA "State of The Art Catalog" 1985

The Irvine World News, July 17, 1986

Art Scene California, Vol. 6, No.5, January 1987

Art Speak - June 16, 1987, New York City

Viechtach Daily Newspaper Bavaria, Germany: July 2004

Visionary Art Yearbook, 2010

Book Cover Art by Irene Vincent:

Kali's Odiyya by Amarananda Bhairavan published 2000

Medicine of Light by Amarananda Bhairavan published 2007

Love Belongs To Those Who Do The Feeling by Judy Grahn published 2008

To Save A Dying Planet by Ron Figueroa published 2012, (Art and Cover Design)

Group Exhibitions:

Miami Art Center - Miami, Florida, 1975 (Juried)

Women Artists It's Time Annual Show - Miami, Florida, 1975

Florida International University Student Shows - Miami, Florida, 1974 – 76

Coconut Grove House Gallery - Coconut Grove, Florida, 1976 (Juried)

Coconut Grove House Gallery - Coconut Grove, Florida, 1977

Juried By Marilyn Schmidt, Ph.D. And Arlene Olson, Ph.D.

Stanford Galleries - Baltimore, Maryland, 1981

Southwestern College, Chula Vista, Ca 1984, Juried By Michael Schnorr

OCCCA Membership Show, 1985

Spectrum Gallery, San Diego, CA, 1987

Amos Eno Gallery, New York City, New York, 1987

Irvine Art Center, Ca. Juried By Dori Fritzgerld, 1988

Fact Gallery, Laguna Beach, CA: Oct. 1994

Concordia University, Irvine, Ca, 1994

Viechtach Gallery, Viechtach, Bavaria, Germany, 2004

Plein Air Art Show, Giverny, France: July 2006

Magical Realists Show, Cadaques, Spain: August 2006

The Space Gallery, Eureka Springs, AK: May 2008

Sandstone Gallery, Laguna Beach, CA: June 2008

By 55 The OC Artist's Co-Op, Santa Ana, CA, July – Dec 2008

World Art Gallery, Ladera Ranch, CA, Nov - Dec 2008

Beauty And The Brush Gallery, Laguna Beach, CA, Oct - Dec 2009

Festival Of Goddesses, Laguna Beach, CA, April 2011

One Person Exhibitions:

Irvine Fine Arts Center, Irvine, CA, Portfolio Gallery 1987

Orange County Center For Contemporary Art, CA, 1987

30-Year Retrospect Show, Laguna Niguel, CA, 2007

School of Multidimensional Healing Arts and Sciences, Costa Mesa, CA, 2011-2012

Impact Health & Wellness Center, Costa Mesa, CA, July – October 2012

Sites:

Mystical, Visionary, and Surreal Art by Irene Vincent http://www.irenevincent.com

Yessy http://www.yessy.com/ivincent108 Features Irene's Giclee prints.

Deviant Art http://ivincent108.deviantart.com Features Irene's political prints.

Travel Experience:

Visited museums in Belgium, Netherlands, Germany, Switzerland, Italy and France in 1974

Visited museums in New York City and in Athens, Greece, 1975 and 1976

Five-day excursions to New York City visiting artists, Museums, and galleries 1974, 1975, and 1976

Trips to Jamaica 1977, Hawaii 1978, Tahiti 1979, New York City, 1980

From 1977 to now, I have lived in California, often going to MOCA, LACMA, The Hammer Art Museum, and The Getty Museum in LA, visiting the de Young Museum and The Modern Art in San Francisco. I visit OCCCA in Newport Beach, The Laguna Beach Art Museum, as well as the Pasadena Art Museum in my local area.

Trip to Mexico City and the Yucatan peninsula visiting Museums and Mayan Archeological Sites 1984

Trip to New York City, Rochester, New York and Toronto, Canada, 1984

Trip to Vancouver, Victoria, and British Columbia, Canada, 1985

Trip to Bangkok and Chiang Mai, Thailand and New York City, 1986

Trip to visit Mayan Ruins of Tikal in Guatemala and Belize, 1987

Trip to New York City, 1987

Trip to Lima, Cuzco, Machu Picchu & Nazca Lines in Peru, and La Paz, Bolivia, 1988

Trip to Native American Ruins, Southwest, USA, 1988

Trip to Vancouver, Victoria, Kootenay Bay and Gulf Islands, Canada, 1989

Mexico City, Mexico - Art & Anthropological Museums, Palenque – Mayan Ruins, 1989

Trip to Mexico: Oaxaca - Ruins of Monte Alban, Mitla, Yagul, and others, Palenque's Mayan Ruins, Bonampak - the sister ruins of Palenque, and Mexico City, 1990

Southwest Ruins- Canyon de Chelly, Oak Creek Canyon, and Sedona, 1990

Southwest Ruins- Acoma Pueblo, Mesa Verde, and Chaco Canyon, 1991

11-11 Psychic and Initiate tour to Egypt - (date connected to Mayan Calendar Event) Cairo, Giza, Kerdasa, Temples of Abu Simbel, Philae Temple, Dendera, Kom Ombo and Valley of the Kings etc. 1991

Trip to Santa Fe, NM and Sedona, AZ, 1994

Trip to Museums and Ancient sites of England, 1995

Trip to jungles and volcanoes of Costa Rica, 1996

Moved to Jemez Springs, NM, 1998

Visited art museums in San Francisco twice in 1998

I went to Astrological Conventions and Art Museums in Atlanta, Georgia; Chicago, Ill. Denver, Colorado; Monterey, CA; Anaheim, CA; etc. from 1992-1999

Moved back to Laguna Niguel, CA in 1999

Trip to India, New Delhi, Rishikesh, Hardwar, Allahabad, Benares, Bangalore, Kerala, Madurai, 1999

Trip to ruins and art museums of Oaxaca And Mexico City, Mexico, 2001

Trip to Vienna and to Reichenau, Austria to go to art museums and to study the old masters mische' technique of using egg tempera and oil paints for a visionary artist's seminar taught by Prof. Philip Rubinov- Jacobson. Stopped in London, England to visit art museums on way home, 2002 and again in 2005.

Trip to Venice, Florence, Sienna & Tuscany Italy to visit art museums and for 2 week Mische' Technique Seminar with Prof. Philip Rubinov-Jacobson in 2003

Trip to Munich and Viechtach in Bavaria, Germany. I went to visit art museums and to further study mische' technique with Prof. Jacobson. June 2004.

I traveled to Williamstown, Mass. and area. I visited the Clark Art institute, the Norman Rockwell Museum, and Frederic Church's home along the Hudson River, 2004 and 2005.

Trip to visit Paris, France to visit art museums. I painted with a group of plein air artists in Giverny, France in Monet's Gardens and in the surrounding villages guided by Cynthia Britain, 2006.

Then I went to Spain and painted with Visionary and Surreal Artists (Martina Hoffman, Robert Venosa, and other great artists) in Cadaques, Spain, home of Salvador Dali. We had a group show. I visited Museums in the area and in Barcelona. 2006.

Trip to art museums and galleries in New York City. 2007 and 2008

I participated in the New York Art Licensing Show in 2008.

In Eureka Springs, Arkansas, I painted in "egg tempera and oil" technique with Philip R. Jacobson, Cynthia Re Robbins and other great artists. We had a group show in The Space Gallery.

In 2008, I went with my mother and brother to Seattle to visit the art museum and galleries. And we went on an Alaska cruise trip. The Glaciers were awesome. I wanted to experience them for a cave series of paintings that I was working on.

I went with my sister Ruth to visit Seattle and the Art Museum and galleries and on to explore the San Juan Islands. We saw the most joyous playing of whales in the ocean.

In May 2009, after my most loving and adoring cat, Timbu died at age 18, I drove up the Coast of Ca, OR, and WA. I visited the de Young Museum in Golden Gate Park. I hiked through Muir Woods and The Trees of Mystery and The Oregon Caves. I was very inspired by the Oregon Coastline. I went to Victoria, Salt Springs Island, and Vancouver. I then met up with my artist friend Donna Hanna Chase and her relatives. We took the Rocky Mountain train to Kamloops and to Jaspers. I drove with them from Jasper to Lake Louise, Banff and on to Calgary. We took five days to hike in the gorges, along waterfalls, along lakes, and up glaciers. I fell and sprained my wrist while hiking down some loose stones at Lake Louise. That put a damper on any painting for a few months. However, the beauty of the trip was awesome, inspiring, and electrifying. From the giant redwoods, the vastness of

the coastlines, the flowers of Butchart Gardens, and the magic of the Canadian Rockies, I stood in awe of the creations of the divine universe and my art shall transform once again.

I drove down through Washington, over to Mt. Hood, through Oregon (the scenic route) and then onto Mt. Shasta. July to Aug 2009. In 2009, I flew a few times to Rochester, New York to help my family.

I participated in the Art Licensing Expo in Las Vegas, Nevada, June 2010.

I flew to Rochester, New York to reunite with my older sisters, identical twins, who had been adopted out at birth. They had just found each other just three years earlier and had become best of friends. It was a special bonding and reunion for all of my family. Everyone was filled with love and my mom who had almost died a few months earlier was filled with joy. June 21, 2010.

During September 2010, I drove up the California Coastline from Dana Point to Point Reyes to meet with my nephew Chris and my newly met sisters. I spent time in San Francisco.

September 2011, I drove up the California Coastline with my new partner, Ron Figueroa, visiting the Redwoods and art museums.

Acknowledgments

For this book I wish to thank a number of people. Gratitude of course goes to everyone in these pages, with whom I shared a memory or two. I also want to thank all those wonderful people who have been a part of my life and are not in this story. I want to re-thank Swami Radha, since transitioned, for planting the seed.

I want to thank my former second husband, Nandu Menon for gently telling me over our ten years journey together to write a book about my art and life. Nandu, under the pseudonym of Amarananda Bhairavan wrote the books, *Kali's Odiyya* and *Medicine of Light*. I learned from his process and dedication to writing his stories. When we divorced, he left me helpful books about writing, saying that I would need them when I wrote my own.

I want to give thanks to my dearest friend Donna Hanna Chase who read my first thirty pages and told me that my story was riveting, she couldn't put it down and she wanted to read more. I thank Donna for her encouragement as well as for reading and editing my entire first draft.

I want to thank my friend, Leonard Szymczack, author of *The Roadmap Home: Your GPS to Inner Peace*, for reading my first five pages and telling me to start with my near death experience and to just keep writing until the book was completed.

Thanks to my dear friend Anthony Smart, a brilliant engineer, author, and creative who spent a half-day reading my first sixty pages and also told me that my story was riveting. Anthony also took a full day to help me edit the first nine pages, along the way giving great pointers on the art of writing. Later on, when I saw Anthony at a party, he asked me how my book was progressing. Having just finished my fifth rewrite and exhausted from editing, I told him I was having doubts about putting it out there. He said, "Irene, it is not

so much about the events in your life as it is about the way you responded to those events. You have to publish your book."

I give thanks to my long ago former-boyfriend Robert Phelps for going into his attic to retrieve pictures of our seven years of travels together, especially to the various Mayan Ruins. These helped me to finish the original manuscript, which turned into two books.

I give thanks to Ron Cohan, my former first husband for reading and editing my first draft. I thank him for his quality critiques and remarks. I appreciated his enthusiasm and encouragement. I also thank him for giving me pictures of our early journeys through life. I also thank his wife Lee, a wonderful artist, who gave me enthusiastic advice. Ron still manages Zia Jewelry in San Juan Capistrano, CA.

I give thanks to my dear partner, Ron Figueroa, author of *To Save A Dying Planet: A Spiritual Science Fiction Love Story*, for his encouragement and help in making the final editing decisions.

I want to thank my friend and teacher of the old master art technique, Philip Rubinov-Jacobson. Philip's book, *Drinking Lightening: Art, Creativity, and Transformation*, is a chronicling of how life and art played a vital role in his soul's journey as well as demonstrating how sacred art is for us individually and for society. It was an inspiration to me.

I thank my friend Angel B of Angel B Productions for editing a several hour film of my 2007 Retrospect Show and turning it into several short youtube videos. Often by brainstorming with me and asking me interviewing type questions she has inspired me to jump out of my safety zones.

I truly thank Mike Robinson, author of *Skunk Ape Semester*, for his professional editing. He gave me great feedback and kept the integrity of my story. And he was highly encouraging.

I thank, Elaine Wilkes PhD, author of *Nature's Secret Messages: Hidden in Plain Sight*, for doing a final quick edit for this book. Her comments about how to get my book out into the world were encouraging and inspiring.

I give thanks to the Southern Orange County Writers Meetup Group, always an inspiring and helpful experience.

With this book, I hope to inspire young people to pursue an education and gain knowledge, just as Miss Curry, my third grade teacher, told us when we were living in the Ghetto. She explained that the only way out of the ghetto was a college education. Miss Curry was so important to me in making it through all my risky adventures. I kept hearing her voice, "Get your college education." And because I got that college education, it made it easier for me to become a successful entrepreneur. I wish to honor all the teachers that have said special words to uplift their students' lives.

Lastly, I'd like to share my definition of God, as used in this book. God is love. God is the energetic magnetism and vibration that we know as love. Words that I use for "God" are The Goddess, Divine Mother, The Divine Universe, The Supreme Inner Most Self, Sweet Lord, Universal Energy, Love, and more. I believe that divine grace surrounds us, it permeates us, and in those moments that our soul calls to it, it is there for us, and we feel it. I believe divine grace appears in many forms, shaped by our religious beliefs, culture, family and environment. God to me is everything and nothingness.

See Irene Vincent's Art in color at: http://www.irenevincent.com